Edward L. Loper, Sr., The Prophet of Color

A Disciple's Reflections

Marilyn A. Bauman

Duncan & Duncan, Inc., Publishers

Edward L. Loper, Sr., The Prophet of Color: A Disciple's Reflections

For information or to contact the author, address correspondence to:

Duncan & Duncan, Inc., Publishers
2809 Pulaski Highway
P.O. Box 1137
Edgewood, MD 21040
Telephone: 410-538-5580

Library of Congress Catalog Card Number: 98-74218

Bauman, Marilyn A.
 Edward L. Loper, Sr., The Prophet of Color: A Disciple's Reflections
 1. Art 2. Artist 3. African-American Artist 4. Teacher 5. Personal Vignettes

ISBN: 1-878647-56-3

5 4 3 2 1

Dedication

Acknowledgments

To the many people who helped me write this book and provided encouragement and support along the way, I am deeply grateful.

Long ago, Kerin Hearn, one of Edward Loper's students, named me the chronicler: the person responsible for getting his story told. I enjoyed writing magazine and newspaper articles about Ed's work, his life, and his teaching. So when I thought about writing this book, I asked myself, "How hard can it be?" How hard, indeed.

These are the people who made it easier:

First, I would like to acknowledge the debt I owe Ed Loper. Because he devoted hours that became days, then weeks, months, and years to answering my endless questions; because he discussed the most painful of his life experiences; because he trusted me to know what information was important and what details would simply embarrass or hurt good people; because he was forthcoming, honest, and articulate, this is a better book.

I hope I have made him proud.

Dr. James Newton, artist and professor in the Black-American Studies department of the University of

Delaware, helped me begin the interview process. Because of his gentle techniques, sensitive questions, and extraordinary knowledge of Wilmington's African-Americans, Ed slipped into the procedure without a struggle.

Janet Neville-Loper, Ed's wife, shared her mounds of newspaper, magazine, and review articles; helped set up the many meetings between Ed and me; fed me; gave me coffee and cold drinks to keep me going; read the manuscript and helped me see what had to be omitted; and, in all ways, made the work go smoothly.

Edward Loper, Jr., Ed's son, and Jean Washington, his daughter, willingly provided details about their childhood and shared personal and sometimes painful memories. If my descriptions of their family life are at all specific and vivid, it is because of their superb memories and generous natures.

Without the encouragement of my daughter, Alisa, I might have let self-doubt erode my determination. She knows a lot about writing books, has written two herself, and constantly reminded me why I was writing this book and what a great job I was doing. Our e-mail correspondences are lessons in courage building.

My husband, Don, provided a safe haven, fielding phone calls and doing the grocery shopping and cooking, so my long weekends interviewing Ed and working at the computer remained uninterrupted. Happily for me, he mastered the intricacies of grocery shopping and cooking so well, he continues to do both.

Lois Crouse, editor *extraordinaire,* read and re-read the manuscript whenever I asked her, never once complaining or running the other way when she saw me coming with pages in my hand. Her scrutiny for grammatical correctness saved me from embarrassment.

Judy Govatos and Bea Lyons listened to me recite what Ed told me, sometimes whole sections of the book that were taking shape in my mind, long before I began to write. Their questions guided me, and their enjoyment of those conversations continually convinced me that this was a story worth telling.

Ed's students, his "gang" as he calls them, eagerly spoke with me about their learning experiences. Their paintings validate the impact of Ed's influence and the importance of more research concerning his art and teachings.

Brian Miller interviewed me for his thesis project and provided valuable insights of his own. His thesis, *Edward L. Loper, Sr., Artist and Educator: An Oral History,* documents Ed's achievements.

Eric Booth's generous and kind encouragement and his book, *The Everyday Work of Art,* always inspired me when I became discouraged.

Peggy Amsterdam, Alisa Bauman, Lois Crouse, Jenine Culligan, Richard Burrows, Judy Govatos, Lanny Lasky, Lynn Luft, Scott Noppe-Brandon, Percy Ricks, and C. Lawler Rogers read the manuscript in various stages of development and provided helpful suggestions.

And a special thank you to Shirley and Michael Duncan who believed in this book and guided me through the wilds of publishing with skill, warmth, and humor.

Table of Contents

Three—Lamentations

Four—The AfterLoper

Foreword

It gives me great pleasure to write about my friend, Edward L. Loper, Sr. After having the opportunity to curate two of his exhibitions, I have grown to understand the essence of Loper's artistic style.

Edward L. Loper, Sr., The Prophet of Color: A Disciple's Reflections provides an exciting living history of a twentieth-century painter and the importance of one African-American artist and his impact on the development of art and art education in America. Indeed, Marilyn Bauman has stitched the fabric of color into the history of an important African-American painter.

The Prophet of Color clearly shows Edward Leroy Loper, Sr., as an important artistic visionary who has contributed to the development of creative African-American imagery through the energy manifested in his works. Although African-Americans have made lasting contributions to our urban culture for more than a century, it has not been until recently that Delaware recognized Loper's art as a major part of its urban diaspora.

So again, let's give thanks to Marilyn Bauman for providing us with a living history of a man who has given so much of himself and his work so that we may all enjoy the richness and fullness of life that is so wonderfully shown in Loper's art.

Dr. Donald A. Parks
Director/Artist and Professor of Art and Art Education
Delaware State University

Introduction

This book was supposed to be a biography.

Edward L. Loper, Sr.: From the Prism's Edge, a retrospective exhibition celebrating this "local legend's" sixty years of painting and teaching, opened at the Delaware Art Museum on February 2, 1996. The exhibit compelled me to write a book about Ed's art and teaching. I had already written about him for the Wilmington, Delaware, *News Journal,* for *Delaware Today* magazine, and for the exhibition catalog.[1] I had known him for almost thirty years. I understood the extraordinary nature of his life and work, "an artsy Horatio Alger" story, Bill Frank, a reporter for the *News Journal,* had called it. A full-length critical biography should have come next. I wanted to be the one who wrote it.

My reason: Edward L. Loper, Sr.—a self-taught African-American artist who grew up in the segregated and racially intolerant atmosphere of Wilmington, Delaware, in the 1920s and 1930s and gave visual meaning to the world he knew (city streets, tenements, railroad trestles, and the surrounding marshes, coal yards, and pool rooms)—is the most determined person I have ever known. He is also the first African American to have a painting accepted to a juried show at the Wilmington Society of the Fine Arts.

Despite all the odds against him, he became a beloved and inspirational teacher to countless students. Intense, tenacious, and inquisitive, Ed inspires powerful feelings—not always positive. I respect and admire him. During the many years I have been his student and friend, he has taught me more than how to paint: He transformed my life by teaching me a new way of seeing.

Consequently, I am not writing a biography.

I would have written a biography for all the wrong reasons: because that was the only option, so no one else did it first (yes, I felt competitive and possessive), because I wanted the world to know him the way I did. All those reasons would have infused too much Bauman into what needs to be an objective narrative. I must leave that for someone else to do.

This book, instead, is a collection of personal vignettes showing the value and meaning of a life devoted to making pictures—Edward L. Loper, Sr.'s, life primarily, but my life, too, and all the other lives he has influenced, the lives lived by artists who have worked, as Virginia Woolf said, "in poverty and obscurity" and in "the presence of reality."

Ed Loper taught his students how to work at making art, not for fame nor fortune, but for the commitment itself. The "work" of art, an experience Eric Booth describes in *The Everyday Work of Art*, a book that celebrates the process, became its own reward.

And we worked hard.

After thirty years, I needed to understand why.

To find out, I had conversations with Ed during the winter of 1996. I say "conversations," because "interviews" makes them sound too formal. I recorded some of them, particularly the first three, when Dr. James E. Newton, a professor of Black-American Studies at the University of Delaware, joined me. Together, we convinced Ed to help us get the facts down while we still could.

We started talking to Ed a few months before his eightieth birthday, after the retrospective had opened and before, as Ed told us, he got over "feeling important."

Then, as I needed more information, I continued to meet with him. Sunday afternoons at 1:00 became what we called "our time." Many days the conversation went on and on well past dark. As we traveled through the events of Ed's life—from the all-black Howard High School basketball and football games to the menial jobs he worked to survive during the Depression; from his stepfather's preaching to his young wife's tragic death; from his work with the Works Progress Administration to his study of art appreciation at the Barnes Foundation in Merion, Pennsylvania, I learned more clearly and specifically how he became the Edward L. Loper, Sr., that the retrospective elevated to a legend.

Then I spent a year trying to decide how to write this book, a year of writer's block so severe I even considered giving up. I felt as if I had a cork lodged in that place from whence all coherent phrases originate. All the interview notes, all my memories of him and interactions with him remained stuck, swollen and fermenting, waiting to be tapped—like the filled beer bag in my son's basement. "My life is so uninteresting," Ed said toward the end of this time, "Marilyn can't find anything to say about it."

I complained to students, family, and friends. All told me I would indeed write the book; I just had to get started. Finally my daughter said to break down the story into small parts, to begin with any recent event that intrigued me in any way, and then keep going that way until I said all the things that were right there to say. After that I could piece together the past information that illuminated the present.

This made sense to me because Ed's story is as intricate as his pictures. It also made sense to me because Ed taught me to paint by showing me how to see one color at a time. I learned to piece together the visual elements of color, light, line, and space into a unified whole.

In January 1997, I wrote the first chapter on a pad in Fort Lauderdale, Florida. While I jogged through the Fort Lauderdale park, I thought back to my daughter doing her Bible study homework during the Christmas holiday. She was reading the book of Jeremiah and telling me about his struggles.

Jeremiah's relentless attempts to root out, to build, and to plant reminded me of Ed's teaching. In that park, on a humid morning, as I ran along a path adjacent to a boat basin, I connected Ed's intense, demanding instruction to Jeremiah's struggle to set the crooked straight. I had both a title and an idea.

In that instant, I knew I would write the book.

I completed the first draft in early June. I understood what I had written only after my slow dot matrix printer ground out fifty-eight single-spaced pages late one Monday night, and I read them.

Ed taught me to paint pictures the same slow, laborious way, surrendering to the artist in me and trusting the process.

This book, then, my reflections on Ed's art and life, is a record of two art journeys: Ed's and mine. In my pursuit of Ed Loper the man, the artist, and the teacher, I intertwine the facts of his life and my reactions to those facts to show what happens to ordinary people who learn and teach the work of art: They experience extraordinary adventures in perception.

Along the way I pay tribute to Violette de Mazia, the art scholar and teacher who enchanted students, including Ed and me, for more than sixty years at the Barnes Foundation. She taught us that "art and life are kin."

Ed's art, his teaching, and his life are inseparable. I want you to experience him the way you would experience one of his pictures, slowly, carefully, and with attention to the myriad details you begin to see only when you look at it for a long time.

Ed revealed himself to me layer by layer. The man I thought I knew when I began talking with him surprised me every step of the way, each detail propelling me to new insights about the meaning of his art experiences as well as my own. I tell you the story by guiding you through the episodes which unwrap the man, the artist, the teacher.

Marilyn A. Bauman

—One—

The Mission

It Must Be Tuesday

"Why did you put this line here?" I hear Ed ask a new student during a Thursday afternoon class. "Why did you leave all this empty space?"

I can't help but listen to the instruction. We work in a small studio, a converted garage in a one-story, green cinder-block house on the corner of North Ogle Avenue in Wilmington, Delaware. Eight women and two men attend this class, and we all keep painting our own pictures as Ed confronts this new student.

She is not just an ordinary new student. Michelle Spellman is an award-winning art director with more than twenty years experience in the field of graphic design. She has worked for Time-Warner, Inc., *Sports Illustrated*, and the 1984 and 1988 Olympics. She developed the first computer graphics curriculum at the University of Maryland and has taught at the University of Delaware and at the Delaware College of Art and Design.

Ed knows this. It doesn't change a thing.

Michelle selected one of the many still-life subjects set up on shelves and cabinets built around all four walls of the studio. She is trying to compose a picture using a cream-colored pitcher and a bowl of fruit.

She's worked on the drawing for several weeks. Charcoal smears her hands and face. Still, her lines are wrong, her perspective skewed, her objects too small. She leaves too much empty space. She draws, Ed tells her, like an art school student. Then Ed gets to color.

"What color is it?" he asks her, pointing to a spot on the pitcher. "No, it's not yellow. Your brain tells you it's yellow. Use your eyes. Look at it. Right here. What color do you see?"

Ed begins working with every new student this way. He is as relentless and demanding at eighty-one years old as he was when I first met him more than thirty years ago.

It does not matter if the student comes to him as a raw recruit or, like Michelle, as an art school graduate. It does not matter if the student is sixteen-years-old or sixty. The timid, sensitive, or insecure beginner receives the same treatment as the more sophisticated or wised-up, long-time committed.

"Humiliation is his technique," says veterinarian Kevin Coogan, a second-generation student, the

son of Joyce Coogan who has studied with Ed more than thirty years.

Ed gives a few instructions. He says to fill the canvas. He says to design the objects to move the eye through the picture. He shows a few examples, pictures by Cézanne or Matisse, perhaps, to give the student ideas on composition.

Then he watches. No student gets it right. So the student begins again. And again. And again.

I watch his assault on Michelle. I wonder why any of us endure this, why so many of us are still with him.

On such days I don't believe he is a good teacher, not if I measure teaching technique by professional education standards. He neither encourages nor affirms; he never compliments; he does not break the task into small parts; he offers no hints, short cuts, or simple tricks; he attacks beginning effort without mercy; he makes students cry.

Michelle cried. After two and a half months of trying to see more than yellow in that pitcher, after two and a half months of begging to stop working on this picture and begin another, she cried. After Michelle left, Dr. Coogan said, "When I was a child, I always knew it was Tuesday because that's the day my mother came home crying."

Not only new students cry.

Professional artists, like me, attend his classes for the camaraderie, we say, or for the structure, knowing we will have to work on a picture at least once a week if we pay to attend his classes. Many will admit he sometimes makes us feel inadequate, unsure, even stupid.

Just recently, I decided to use one of his still-life arrangements housed in a corner of his studio as a subject. I positioned myself to one side and very close to it, so I could look down into the jug as well as directly at it. Then I could play with the perspective and the spatial relationships. Because of this position, and because two other students closed me in on the left and the right, I felt claustrophobic. Worse than that, however, as soon as I started, nothing felt right.

My canvas felt too small. My drawing felt boring and tight. I never got into it. Color shapes appeared to me, but my attempt to apply what I was seeing felt ordinary and dull. I complained a lot.

After I had covered the canvas with color, Ed suggested I paint lines, bold, heavy lines, around all the objects, something I never do anymore. Since I already had no hope for this picture, I tried it; and I felt even worse. Now, I decided, the picture did not look like I painted it, but like someone else's picture, like his, for instance. It took me six long years away from him to make pictures that looked like mine, and I just knew I had slipped back to a former, less personal, time and place. I felt miserable.

Oddly enough, this experience followed two solitary and productive weeks painting in Gloucester, Massachusetts, a time of absolute connection with my two subjects, excitement with and interest in each of them, and pure pleasure working

with the clear coastal light. I even liked both finished pictures and felt satisfied with them, a very rare feeling for me.

Cramped as I was in this dark corner of Ed's studio during the warm and humid autumn, I decided the best I could do was persevere, get it done, then bury the painting in the storage bin in my basement.

Because of my location, Ed could not easily see my progress, and I showed it to him only when I finally felt finished.

"Finished?" he ranted. "Look at this mess. The color is terrible. You have no darks and no lights. It is the same all over. You have to look at the differences among those three objects. One is cool, the other hot. One is lighter. When are you going to start looking?"

My face felt hot. My fingers tightened around the brush I wanted to stab him with. My pride rose up and screamed at me: "Why do you take this from him?" I drove home that day, drained and discouraged, asking myself, once again, why I continued to work in his studio.

More than fifteen years before this, I stopped going to his studio. I needed to go it alone and discover where his teaching ended and my ideas began. I worked alone for six years and in that time grew confident. My motto became: If I paint bad pictures, they will be bad Baumans, which is better than good pictures that are more Loper than Bauman.

When I felt sure I could stand my aesthetic ground with him, I returned. For the camaraderie, I said, and for the structure. And because I missed him terribly.

In the early days of my return, we seemed to have developed a truce. He suggested, not demanded. He prefaced suggestions with "I have no right to tell you this, but. . . ," and I loved him for it.

This current criticism felt like a throwback to the earlier days. But I now knew something I did not know then: I did not need him to help me make my pictures. I needed him, instead, like a musician needs a band: to share the vision, explore the possibilities, and enjoy the process. We spoke the same language, were moved by similar visual qualities, and liked to argue.

I came to understand he needed me, and his other students, for his own reasons: We validated his discoveries; we made him feel important. We were his people, the chosen ones, destined to see color or die trying. Like the prophet Jeremiah, Ed had the requisite "fire in his belly and burning in his bones" to keep us all going.

Therefore, we tolerate his outbursts, and we make excuses for his incivility. We also feel devoted to him.

"You are obligated," he once said to me. To Ed, "obligated" means more than compelled. "Obligated" means pay-back time. It means commitment.

The Covenant

Ed first felt obligated to teach. Then he felt obligated to continue making pictures. Finally, he felt obligated to share with his community everything he ever learned, whether they wanted to know it or not.

Thirty years ago, when I became Ed's student, I found his tenacity unusual. I wondered where it came from. Consequently, when I met with him to write this book, one of the first questions I asked him was why he had such resolve. He had no trouble telling me why.

While some artists teach to bring in a reliable paycheck, Ed felt compelled to teach for a different reason. He taught what he was learning as he made pictures, and he continued to share his discoveries with students, not because he needed their money, but because he had no choice. He had made a deal with God.

This is how it happened.

During the 1930s, American painter David Reyam was Ed's Works Progress Administration (WPA) supervisor. Reyam had studied in Paris with William Adolphe Bouguereau, the award-winning French painter who taught at the prestigious Académie Julian, a private art school opened by Rodolphe Julian in 1868. The Académie Julian stressed accepted art-school philosophy: excellence in making unimaginative copies from a cast or nature. In 1891, Matisse found the instruction so stultifying, he left. Reyam, however, was perfectly suited to his task.

His job was to train Ed and other Wilmington artists to produce paintings for the Index of American Design, a record of American craft traditions from early Colonial times to the close of the nineteenth century. It was one of the most ambitious projects ever undertaken in the arts, and hundreds of artists from thirty-five states rendered these objects in watercolor or tempera.

Reyam was a skillful technician; he was also kind, patient, and understanding. He knew Ed had no formal training, but he discovered Ed could handle brushes and pens. He also saw Ed possessed a natural sensitivity to color.

Reyam also understood Ed's desire to be an artist. As a young man, Reyam struggled with his family for their permission to pursue his art. But when Reyam returned from Paris, his family discouraged his interest in art and encouraged him to run the family business instead. During the Depression, the family sold their factory to DuPont, the giant chemical company spawned, in part, by the great profits the DuPont explosives manufacturers amassed during World War I. As part of the deal, DuPont brought Reyam to Wilmington to work for the company, with one stipulation. Because DuPont did not hire Jews, Reyam concealed his family name, Mayer, by reversing the letters. By the time Ed met him, Reyam attended a Baptist church and had retired from the

DuPont Company.

Reyam taught Ed the fundamentals of drawing and painting, the skills Ed wanted desperately to learn, such as perspective, values, and proportion. "He was the first person to tell me that when you're painting you do not paint the same color all the way around the object, that the color every inch is changing," Ed told me as we sat talking about his WPA experiences late one February afternoon. "Of course, Reyam called it value, the degree of lightness and darkness."

Reyam's most important contribution, however, was something else: He said that if Ed continued to paint, he'd be the most important black man in the city of Wilmington.

Ed then asked God for more than that. "I asked God to make me the best painter in Delaware," he said. "I knew Reyam couldn't conceive me being better than a white person," he admitted to me, winking, "but I wanted to be."

Ed felt "picked," he said. "God had this idea for me to be an important painter, and I decided I had to teach whatever I learned, as fast as I learned it, because if I didn't pass it on, I'd be doing a disservice. I decided I was selected because I had a stick-to-it-tiveness; I wouldn't give up. Later I believed it was my obligation. If God was going to give me this, I had to pass it on."

"Do you really believe that?" I asked him, skeptical that he felt such a connection to a God he frequently argued did not exist.

"Yes, I do," he responded. "I can't conceive of any other reason. Every other black man who came along they knocked down, and he gave up. I did not stay knocked down."

"But your drive?" I questioned. "Come on, it's unusual. I never met anyone as determined as you."

"That came from being an athlete, partly," he continued. "Athletes don't give up. A lot of people give up if they don't get what they want right away. I never expected to get it right away. Every time I looked around I found someone everyone said was a 'great artist.' I looked at the work I was doing, and I thought mine was better. I needed to win. And I knew I would never get something for nothing. I knew I had to work hard to get better."

The Method

The WPA's Delaware Division and Easel Division required community service. Walter Pyle, in charge of the Easel Division and the nephew of the famous illustrator Howard Pyle, suggested Ed teach at a children's correctional institution, the Ferris Industrial School of Delaware (now called the Ferris School).

Ed did not have credentials. A few years out of high school, his only art training the WPA, he had never taught anyone anything.

Ed would go to the school at Centre and Faulkland Roads, at lunch time and eat with the

boys, then walk with them to an outside fire escape. They passed mattresses set out to dry in the sun. As they climbed the steps to the landing, the boys would tease each other about who wet the bed the night before. Ed unlocked the door, and they entered a small classroom with tables, chairs, and a blackboard.

Ed talked to them about what he thought pictures were about, and he taught them all the same skills the teachers at the WPA taught him. He taught them to draw so well and, later, to apply show-card color (a water-based paint made with a simple glue-size binder) with such skill, his students started winning all the prizes in the state student shows. Walter Pyle told him, "You teach too hard, Ed. The work should look like children did it."

I remembered my own first teaching jobs, how nervous I felt, how inadequate. I asked Ed if he felt insecure with the boys or frightened by their criminal backgrounds. Did he worry he did not know enough to teach well?

Never.

"I knew more about painting than they did," he said. "And I was strong. You had to be tough if you were black and lived over the 11th Street Bridge. I could beat those boys, and they knew that. But they respected me, not just because they wanted to, but because it was the rule there."

"I enjoyed it," Ed told me, laughing, as we talked in his studio after class one day. More than sixty years later, his students now work in a room crowded with paint-crusted easels, shelves of art books, a collection of still-life objects—vases, teapots, plastic and silk flowers, pieces of cloth—stuffed into cabinets, spotlights attached to bookcases or suspended from wire, a small sink, gas heater, and stained carpeting. "My boys kept winning; they were winning the prizes as the best in the state. It was just like football had been for me. I taught very hard because I wanted them to be 'better than' all the other kids, just like I had to be 'better than' everyone else when I played ball."

"We had a wonderful time," Ed continued. "These were mostly black kids. Nobody thought they could do anything. They were not supposed to be worthwhile. I felt proud at what they could do. Sometimes, ten to fifteen years later, I had young men come up to me and thank me for teaching them how to draw. They got to be proud of themselves. Just a little while ago, I went to a dinner and a sixty-year-old man, a big man, more than six feet tall, called to me, 'Mr. Loper.' He was one of those kids, and he went on and held down a job and had a good life."

Ed's next teaching opportunity came in 1942 when he started working in the tanning division of Allied Kid Company, the leather factory located at 11th and Poplar Streets in Wilmington. Ed was one of the first black men to work there. Saul Cohen, a short, powerfully built, highly organized and meticulous businessman as well as civic leader, was the head of the Wilmington branch. As a boy, Cohen had

joined his father in the leather business in Boston. In 1921, he ventured out on his own as the principal owner of Lynn Tanning Company, specializing in tanned sheep and goat skins. He merged his firm with H.S. and M.W. Snyder in 1926, then left in 1928 to start Bell Leather Company, which merged with Allied Kid the following year. He combined the businesses and moved to Wilmington in 1931.

Cohen had seen Ed painting a picture of men pulling wet leather out of drums, liked the picture, purchased it, and offered him a job.

Soon Alex Ulin, Ed's boss, said he and some of his friends wanted to learn how to paint pictures. Ed went to his house once a week and taught them. None of these white men thought this odd, even though in segregated Wilmington "white folks did not get taught by black people," Ed told me, grinning.

Saul Cohen also offered Ed the use of a room on the third floor of the factory in which to teach. Students like Marge Hackett, who stayed with him for thirty-five years, attended those classes. Marge still remembers walking six blocks after work to 11th and Poplar Streets and climbing the steps to the top of the office building connected to the factory. She also still remembers the lack of heat. It got so cold that one of the models left and never came back.

After that Ed taught at the Jewish Community Center, the Wilmington Society of Fine Arts, the Delaware Art Museum, Lincoln University, and finally his own studio, a converted garage in his former North Ogle Avenue home in Wilmington.

From the start, Ed's teaching role model was Big George Whitten, his woodworking teacher at Howard High School, the state's only high school with grades nine through twelve black children could attend (Dover's Delaware State College offered black students eleventh and twelfth grades). In 1866, the Delaware Association for the Moral Improvement and Education of Colored People organized and met at the home of Samuel Hilles, a Quaker educator. Through its efforts, many black schools, including Howard, were established.[2] Named for General Oliver Otis Howard, an American philanthropist and Civil War officer, Howard grew from a five-room brick building at 12th and Orange Streets in 1867 to a four-column entrance, two-story structure at 13th and Poplar Streets in 1928.

Primarily, Whitten instilled in Ed a tenacious appetite for learning. In addition, he was a crude, tough-love role model, a teacher who demanded complete, unquestioning compliance from his students while providing them with real-life strategies for dealing with the discrimination they were sure to face. Whitten told his students when they dealt with white people they would have to find ways to make bad situations work for them.

Whitten himself graduated from Drexel University and took a job in a Philadelphia frame-making shop. Despite his degree and his skills, he was hired to sweep the floors. Ed told me Whitten watched everything everyone did, stole all their ideas, and

"got so darn good at making frames" eventually he was permitted to join the white men to make them.

At Howard, Ed explained, the teachers were unusually good, experts in their fields. Mrs. Bowser had lived in France and spoke French, not just taught it. Gwen Redding taught Shakespeare by having the students act it, not just read it. "She was a super actress herself," he said, "and moved and spoke like one."

During those years, according to Ed, the quality of the teaching at Howard High School was as good as Tower Hill School, the prestigious school rich white kids attended. When I raised my eyebrows in disbelief, Ed elaborated. He knew he worked from books sometimes thirteen years old, handed down from the white schools with a list of white kids' names in them. But he insisted his teachers made up for that.

"Our teachers went to college and got all kinds of degrees, but since there were only a few black colleges and only a few high schools blacks could attend, they all couldn't get jobs. In Delaware, Howard High was it. So we had teachers who should have been teaching in colleges or working in industries. Our chemistry teacher, John Taylor, couldn't get a job at the DuPont Company, so he taught us. Later, during the war, he filled in for the white guys, and DuPont finally hired him."

Howard High School teachers taught him more than subject matter; they taught him a relentless drive to be "better than." They also taught him to respect learning and take pride in the school building itself, even if the conditions he had to endure were less than perfect.

When Ed's team practiced for football games, for instance, the boys walked from Howard High School to the football field on Northeast Boulevard and Vandever Avenue, a hike of two miles. When Ed first went out for football, they walked to Second and Dupont Streets, a distance of four miles. Since these fields were in public parks, blacks could use them. Nearer fields were "whites only." Their coach, Mr. Naylor, taught biology and science, but received no compensation for coaching. The team did not receive uniforms, helmets, or shoes, as did the white schools' teams. The band used donated instruments.

Nevertheless, Ed loved his school and still takes pride in the resourcefulness of its teachers and students. When he and his son, Eddie, walked me through the building one cold February day in 1998, Ed marveled at how little it had changed in the more than sixty years since he graduated. From the highly polished concrete-block entryway floor to the oak doorways and window frames, the building stands as elegant testimony to the achievement of students like Ed who learned there how to make their way in a hate-filled society. Gold-leaf lettering on a heavy oak door signals the Auditorium, a sparkling room of perfect oak seats, the upper level of seats set off by blue and white banisters. The stage, in Ed's time, also served as the basketball court and dance floor.

Folding doors downstage opened to the court. After the games, students danced on the stage, with the best dancers rewarded by dancing in a spotlight. After the stage was renovated, the court became the music room. Later still, it became the Harmon R. Carey Gallery of the Afro-American Historical Society. The gallery displays two of Ed's paintings and one of his son's, Eddie, Jr.

Each classroom has oak-inlaid, highly polished floor boards. H203, the former Music Room, which served as the setting for Ed's first school art exhibit in 1936, includes a raised platform stage. An early 1950s renovation added a large, rectangular skylight.

Room 104 served as the Library when Ed attended the school. Students studied at large tables in the center of the room which was lined with oak bookcases.[3] It is now the Pauline A. Young Memorabilia Room and contains the basketball Ed's team used when it won the 1932 South Atlantic High School Athletic Conference. Ed thought the ball, slightly deflated after sixty-six years, looked like a "dried up old prune." Inscribed on it are the names of the players, managers, and coach: J. Ward, E. Loper, J. Benson, Capt. J. Redding, W. Moore, O. Brewington, H. Davis, H. Gibbs, H. Carey, H. Wright, coach N. Reed, managers R. Bolden and C. Crawford.

All of this merely underscores the message Ed received: If it was basketball or football, his teachers said, "If you're going to go to a white school, you've got to be better than everyone else on the team. Not equal. Better than. Then you'll play, because they want to win games."

"You must excel," he was told. "Otherwise you don't have a chance."

"You were told you *could* succeed, weren't you?" I asked him.

"We were told we were terrific, and we could do it," Ed responded. "Our teachers told us we had to lead the way, be trailblazers. We had to show it could be done. And because we were black, we had to work that much harder."

In Whitten's shop class, held upstairs in a small building adjacent to the main building, the students had to do so well to please Mr. Whitten that to this day Ed's eighty-five-year-old friend, framemaker Richard Fleming, says to himself, "Mr. Whitten would be raising hell about this," every time he doesn't do something perfectly.

A man replacing a countertop in Ed's kitchen recently told Ed he had been one of Whitten's students at Howard High. "I did not like that damn man," he said. "Every time I stopped paying attention, here come a board at me." Whitten obviously did not teach gently.

"He threw something at you because you were not going to waste his time and you were going to do what he said. 'If you're in my class, you do what I say,' that was his theme song," Ed told me happily, obviously approving of the technique.

"He taught by saying you were dumb," Ed continued. "He'd say, 'You're dumb, boy, but you can learn it.' I once got into an argument with him, and

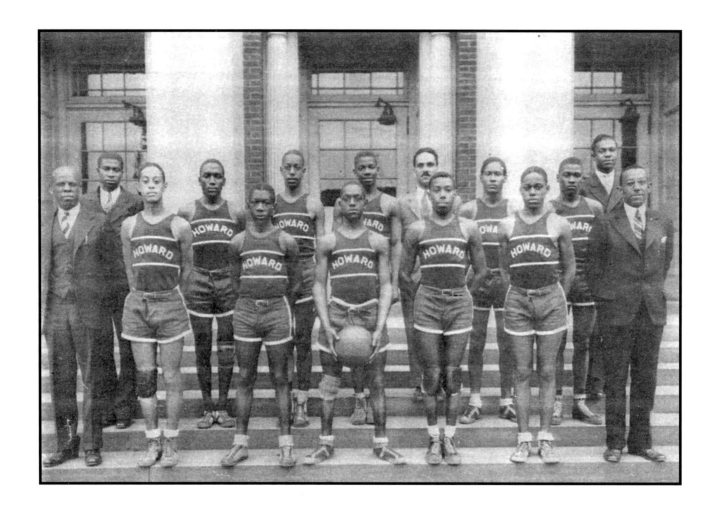

South Atlantic High School Conference Champions: First Row, left to right, George Johnson (principal, Howard High School), F. Davis, Ola Brewington, Joseph Redding (captain), Joseph Ward, C. Moore, N. Reed (coach). Second Row, left to right, Clifton Crawford (assistant manager), Herbert Wright, Howard Gibbs, Johnson Benson, A. Wheeler (physical director), Edward Loper, Harmon Carey, Robert Boulden (manager).
Courtesy of Howard High School Alumni Association.

I told him I had a right to my opinion, just like he did. Whitten said 'Shut up, boy. You only have a right to an opinion when you know something about the subject.' I was so mad, I felt like hitting him. But he was right," Ed affirmed, shaking his head in agreement.

That's how it was at Howard High. To this day, when alumni are invited back to attend the observance of African-American Heritage Day, that sense of pride continues. On February 20, 1998, I met Ed and his wife Janet at Howard High School, and I found myself surrounded by teachers and former students, all of whom remembered something about this man Edward Loper they consider the "Dean of African-American artists."

John J. Jackson, Ed's distant cousin (Ed's grandmother, Hannah Jane Bratcher, was John's grandmother's cousin), told me Mr. Gardner, the math teacher, announced to John's class in 1953, thirty years after Ed had graduated, that he always knew "that boy [Ed Loper] would never amount to anything. He was lazy, did not pay attention, and only was interested in sports and girls. And here he is an artist." John told me the story with delight, grinning at Ed and exclaiming, "That man never thought much of any of us who couldn't easily learn geometry and algebra."

Ninety-two-year old Luther Porter, Ed's former history teacher, asked Ed and Janet to stand next to Ed's 1942 painting, *11th Street Bridge*, so he could take a picture of them. Small, frail, and soft-spoken, with a low-key sense of humor, Mr. Porter listened patiently while Ed chastised him for awarding Ed a B+ in social studies and not an A like he gave Margaret Johnson. "It hurt me," Ed told him. "I suffered all my life because of it." Still unimpressed, Mr. Porter smiled sweetly and told him to "get over it."

Ed's classmates, teachers, friends, and neighbors feel loyal to this school and continue to encourage each other. That's how it was in Ed's neighborhood. Everyone pushed him. He was expected to do well, and no one complimented effort.

"I was a running back and pretty good, I thought," Ed told me late one day as we talked in his living room. "One day we played Dunbar High School, a Washington, D.C., school. I threw four touchdown passes, and we won the game 27-7. I'm feeling real good, and after I showered and dressed, I walked home. It was getting dark, and the older men who had been to the game are standing on the corner, talking. Mr. Les Kane, a former baseball player, says to me, 'Boy, you made a damn fool of yourself out there. You were supposed to guard that guy.' I didn't tackle the kid who made the only touchdown for Dunbar, so that was thrown in my face. No compliment for what I had done. No man gave a young man credit. I thought I did a good job. We won! And I didn't do enough. You just couldn't do enough," Ed told me, sighing, as J. Rufus Caleb, a playwright interested in writing a theatre piece about Ed's life, joined me in Ed's living room. There, in that cozy Graylyn Crest house in suburban north

Wilmington, I felt my stomach tighten. If I had been criticized this way, timid and insecure as I am, I would have felt devastated.

"Didn't this hurt your feelings," I asked him. "Didn't you feel defeated?"

"Not at all," he laughed. "Just challenged to do better. I couldn't let it happen again."

"Isn't that the way it was in black neighborhoods?" he asked Rufus.

"I did not go out all weekend if I made a bad play," Rufus admitted.

I felt like I had entered another world. Here I was, a middle-class white woman, trying to understand the meaning of sports in the black community. I worried that my non-athletic background, my limited understanding of the appeal of sports in general, coupled with my insular white experience, would prevent me from doing justice to Ed's reality. Self-doubt gripped me like the flu. "Could I write this book? Should I be the one writing this book?" I asked myself.

I did not share my concern with either Ed or Rufus. I went on listening to them talk about sports, and then I went home.

This interview opened up more questions: Yes, Ed was resilient and tenacious and driven to excel, I told myself as I drove home. But that does not explain his students' attraction to him, many of them women, why they began to seek him out and why many, myself included, stayed with him for decades despite his "unpolished" teaching techniques. It does

not explain why, for his sixtieth birthday in 1976, his students gave him a trip to France. Nor does it explain his inquisitiveness, his relentless search for answers to aesthetic questions no one seemed willing to provide.

The next time we met, I asked Ed why he thought so many women studied with him for so long.

"I was a fairly nice-looking man," he told me, grinning, as he sat painting in his den. "I talked with them about things that mattered to them, and they told me things that were bothersome to them. They wanted to have something to say about their lives, about the meaning in their lives, or the lack of it. Their husbands thought they had a cute hobby, that they were passing time. Their men did not see them as having intelligence, aspirations, dreams. I respected them. I coached them. I wanted them to prove they were good painters. I would do anything I could to make that happen."

"So they grabbed onto you like a savior?" I asked him. "Did I do that? I faced resentment in college and later in graduate school from male professors. They actually told women students we were taking the place of men who needed to be there to make a living. We were told we would just get married and have kids and never go to work."

"Boy, they gave you a hard time, didn't they?" he laughed.

"Yes, and it was difficult to break away from that indoctrination. But when I met you, you had

such intensity I felt I had to learn what you taught to save my soul. It felt that important. I can remember relaxing into that, as though I let your drive propel me."

I wondered if other students felt that way. I decided to talk with them. I hoped they would help me answer my questions.

The Followers

Testimonials—

I got lucky. In the spring of 1997, Ed's Tuesday night class held an exhibit of their work at the Lorelton, a school converted into elegant "senior living with a personal touch" apartments on West Fourth Street, a few blocks from Ed's studio.

There, in the spacious lounge area on the lower level, I had a captive collection of students, and I made my way around the room asking each of them the same three questions. I wanted to know what brought them to Ed's class, how long they had studied with him, and what they had learned from him.

Maddalena Personti joined Ed's class in 1970, encouraged by one of his students, Charlotte Pappa. Maddalena had never painted before, had never heard of Cézanne, and thought the class would be fun.

"He was a stern son-of-a-gun," she told me, smiling, as she described going through nine, three-inch pieces of charcoal to draw her first picture. Ed finally told her she could start painting with one of his typical "almost" compliments: "Well, you can almost draw," he said.

Then, after only a few years in Ed's class, she moved to Maryland and for twenty years painted on her own with watercolors. In 1994, she returned to Ed's class and found him "more mellow."

Maddalena believes she wanted to be a good student for Ed because he invested so much energy into teaching her. "His demands are motivated by love," she told me. She felt inspired by his passion.

She now teaches art classes at the Lorelton. Maddalena modifies what Ed taught her to meet the needs of her students, some with limited vision and others suffering from the effects of strokes.

Kerin Hearn, director of corporate communications for Blue Cross Blue Shield of Delaware, had taken art classes before she went to Ed. When she lived in Virginia, she studied oil painting with a teacher who taught her to paint with sepia washes like the old masters. After she moved to Wilmington, she took an orientation to painting class at the Delaware Art Museum which she found unexciting.

She shared her boredom with Lefty, a man who looked like a hippie, with a blond pony tail and disheveled clothes, who sold paint supplies to students. He suggested she attend Ed's classes.

In her very first class, an older man worked on a painting next to her, and Ed put his arm around

his shoulder and told him to look at what Kerin was doing. The man slammed his paint box shut, left, and never came back. She has been Ed's student ever since.

Kerin says Ed shepherds her in the direction she is going. For example, he introduced her to the palette knife—a slender, limber blade, four to six inches long, with tapered or rounded tip, used instead of a brush to mix colors on the palette and for painting. Then he showed her work by Nicolas de Staël, the twentieth-century Russian-born artist who moved to Paris in 1938 and developed an intense, personal, and dramatically expressive style. Kerin loved de Staël's slabs of juicy color, and she applies her own vibrant colors with rich abundance.

In her view, this is one of Ed's strongest teaching devices: educating an individual student's vision by showing the appropriate artist's work to study. In so doing, Ed also teaches art history and appreciation. More than that, Kerin says, Ed is like a father and a best friend. He has seen her through a divorce, job changes, and child-rearing. She thinks of him as a member of her family. During one trip to Quebec City, her daughter Marcy, then six years old, told Ed she wanted to marry him. When she later changed her mind, Ed asked her why. She said he was too old for her.

"Race never entered the picture," Kerin told me. "We all functioned like a big family, going to Quebec City together, having picnics there, birthday parties, dinners in restaurants."

Cherie DeSalvo, a registered pediatric nurse at St. Francis Hospital, studied painting in Germany before she married and had children. Cherie had not painted since her daughter was a year old, but three years ago, when her twenty-six- and twenty-nine-year-old children presented her with brushes and paints as a Mother's Day gift, she decided to go back to it. Betty Ulrey, one of Ed's students, recommended Ed.

Cheri liked him from the very beginning. Although she admits he was "kind of tough," she says he's been kind to her.

Ed first told her to draw something for him. He watched her and then said, "Okay, you can draw. Let's see what else you can do."

She did not see colors right away, but caught on after a month. "It's as if God said, 'Here is the right teacher for you,'" she told me.

Al Staszesky, a sheet metal worker who teaches various drawing, painting, cartooning, and figure classes at The Art Studio, the fine arts department of New Castle County, says Ed is one of the "few people" in his life who have "had an influence." He joined Ed's Tuesday night class in 1972 when his wife's friend suggested it.

Al believes Ed took a talent he already had and developed it. He sees his association with other artists in the class and with Ed himself as an "inspiration." He also feels grateful to Ed for urging him to attend art appreciation classes at the Barnes Foundation.

Ten years ago, when Al moved from Wilmington to West Grove, Pennsylvania, he stopped going to Ed's class. He continued wood carving and sculpting, but stopped painting with oils. Then, when his kids grew up and left home, he felt a big void. The void got larger and larger, and Al decided it was "time to put a plug in it."

Now, after two years back in the Tuesday night class, Al claims Ed is less argumentative and more mellow. "He is at least open to some discussion," he says.

And he credits Ed with giving him the confidence to teach. As Al instructs his own students, Ed's words, given a personal spin, come out of his mouth. I know this to be true.

During the fall of 1997, I attended Al's Elements of the Figure class at The Art Studio. I heard Al say, "Don't let your brain get involved. See the line with your eyes, take it through your heart, and draw it with your hand." I have heard Ed say, "Seeing is a learned thing. It is not natural instinct. Once you learn to see as an artist, the world will never look the same to you again."

Bronise Dunnington came to Ed's class because she had seen his paintings in plastic surgeon Dr. Kim's (one of Ed's students) office. She found them "juicy" and "glowing." She has been with Ed for seven years.

Bronise studied at the Dayton Art Institute and majored in art education at Ohio State University. When she moved to Chadds Ford, Pennsylvania, she studied painting with Carolyn Wyeth, Andrew Wyeth's sister, who taught in the original N.C. Wyeth studio. After she moved to West Town, Pennsylvania, she completed her education as an English major at West Chester University.

During Bronise's first few classes with Ed, he kept criticizing everything she did. She felt like crying. "I can't put up with this," she told herself. She would question why she endured his "indignities." But she persisted, telling herself that sometimes something that is worthwhile is hard to achieve. Now she calls Ed "an old pussy cat."

Those five students, Maddalena, Kerin, Cherie, Al, and Bronise, revealed some essential facts about Ed's teaching. He can be tough on new students and, generally, toughest on those with art school training. The initial "seeing" of color can take the most effort and be the most frustrating, but Ed never gives up on a student. The atmosphere is more like joining a family than it is like joining an art class. Students stay not only because they get hooked on painting, they become devoted to Ed.

Sometimes the investment of time pays dividends much later. Martha Barnes, a twenty-year student, told me she had not realized when she started painting how much it would mean to her when she was old. I talked with Martha one warm day in June as she was painting near the Brandywine River across from the Wilmington Zoo. Ed teaches a week-long class there each June.

Now almost seventy-six years old and wid-

owed, Martha's major interest is painting. "Most old people are bored," she told me. "But painting increases my enjoyment of life. I see so much color in everyday things."

Ed does not coddle those students who come to him with very little background. New students do not receive any introduction. Ed makes them jump right in.

Jane Mitchell, the first black nurse at the Governor Bacon Health Center in 1948, later director of nursing at Delaware State Hospital, came to Ed's class as a raw recruit. Grace Paul, a close friend at the hospital, urged her to join the painting class she attended and "could not live without." Grace told Jane the class was "a pleasure, a joy."

Jane replied, "I can't even draw a straight line." Jane told me she had no idea what painting was about. The thought of learning to do it never crossed her mind. She only went to the class because Grace invited her.

As I sat in Jane's living room in Delaware City, with sunlight illuminating her vivid, decorative paintings hung all around the room, she told me that when she entered Ed's studio for the first time, she was stunned to see a nude woman lying on a table. Jane just stood still, frozen in panic. She did not mind the nudity, but she did think an apple on a table might be easier for a beginner.

"Come on, come on," Ed urged her. "Get to work."

She did the best she could to make a drawing, which she says was pretty bad.

The next day she went to Hardcastle, a gallery now located in Centreville (a village about seven miles northwest of Wilmington on the Kennett Pike, an area affectionately called "Château Country" because of the preponderance of large estates nestled among the rolling hills), but then both a gallery and an art supply store on Delaware Avenue in the city. She asked for the "Ed Loper box" and for eleven dollars purchased all the supplies she would need.

Ed, she said, changed her whole way of looking at the world. "The classes are not just about art," she insisted. "He took us to Quebec City. Even though I had been to Quebec City for skiing, the classes there offered an opportunity I did not expect: putting Canadian scenes to canvas. His tours of museums and galleries taught me how to appreciate works of art."

Jane's husband, Littleton Mitchell, president of the Delaware chapter of the National Association for the Advancement of Colored People for thirty years and active in the civil rights movement in the 1960s, listened as we talked, but now he interjected another idea. While Ed opened up new avenues of travel and art appreciation, the "classes also became an all-around learning experience, helping people to understand the various cultures in the class."

Ed transforms lives, he teaches seeing, he builds skill and expressiveness in painting, and he develops friendships that contribute to racial, social, and religious understanding. Students also never get his

words of instruction out of their heads.

One such student, Lyn Young, a math teacher at Wayne Central Middle School in Ontario Center, New York, came to Ed's class because of me. In the summer of 1975, Lyn, pregnant with her second child, moved to Arundel, a suburban development of traditional colonials and split-level homes southwest of Wilmington. One day at the Arundel Swim Club, she mentioned to my neighbor that she'd like to take a painting class to continue a hobby that started when she was in the sixth grade. My neighbor told me to visit with her and tell her about Ed Loper, so I did.

Lyn tells me I knocked on her door, and when she invited me in, I "whipped" around her house in my intense way, saying, "You paint? Well, then you must paint with Ed Loper. After you have your baby, come see me, and I'll introduce you."

She did just that. I found Lyn at my door one warm day the next spring with the new baby. I had no idea how hard it was for her to ring my doorbell.

"I felt so intimidated by your energy," she told me. "I walked past your house over and over again trying to work up the courage to ring the bell. I thought of myself as having a hobby, and I was really afraid Ed's class would be too advanced for me."

Lyn says she knew she'd be hooked, however, when she saw my paintings on the walls of my house. "They were not fluffy," she told me. "They were substantial pictures, heavy. I liked that."

When I brought her to one of Ed's classes, she walked into Ed's studio and saw a whole room of people doing that kind of work. Her description: "Wow!" She had never seen such intense pictures before. She wanted to learn how to make them.

She joined Ed's outdoor summer class at a spot on the Brandywine River behind the Delaware Art Museum. There she learned her first lesson about painting on location: If it's hot, find shade. She had never worked outside before, did not know how to choose a subject, and Ed "did not help much," she said. He just told her to look around and get started. The painting she finally finished, she said, "was horrible." Instead of discouraged, she felt challenged to "get it right."

In the fall, back in the studio, she chose a still-life subject, a green pot with fruit around it, and found it easier. She learned to put color next to color and felt more comfortable. This time, when she was finished, Ed said, "Mrs. Young, my, my, you really can paint."

For the next two years, Lyn got involved with this group "big time." She felt like she was part of a club. But her husband's job required that they move, so Lyn made a deal with him: She would not complain about moving to Albany, New York, if he would not complain when she went off to paint in one of Ed's summer classes.

She joined the class in Quebec City in 1980 and 1981, and she joined the class in Provincetown, Massachusetts, a year later. Although she never attended another of Ed's classes, his teaching stayed with her.

She began to paint still-life subjects in her own basement. She found it lonely and cold. But she persevered.

In the summer, she forced herself to go to Round Lake, a former religious retreat, with Victorian houses remaining on the property. She painted on weekends while her husband baby-sat the children.

She found this very hard. She had no one to encourage her, and she lacked conviction. She'd wake up on a Saturday morning and say, "I don't want to go out there." But she'd force herself.

"Why?" I asked her during a long phone conversation one Sunday night in September 1997.

"Some people go to church because they feel guilty," Lyn told me. "I felt guilty not painting. Ed had taught me so much, and I knew I'd never paint with him again. I did not have the money or the time to attend his summer classes. The still-life subjects in my basement bored me. I just knew if I did not go out on my own, I'd never paint again. Even though I had five million other things to do, I gave myself permission to paint."

The work got easier as Lyn grew more confident. While she did not produce many pictures, she kept at it, turning out three paintings a year some years, sometimes less. And, after a move to Rochester, New York, as her children got older and left home for college or moved away, she and her husband took vacations to places she could paint, like Spruce Head, Maine, and Block Island, Rhode Island.

Ed talks to her all the time: She hears him in her head. Her husband Mark has learned appropriate phrases as well. Mark will stand behind her as she works and say, "Your color pieces are too large. Where are your lines? Are you skipping? Remember, color next to color. Lighten the lights and darken the darks."

"He may not know what any of that means," she told me, "but he's got the lingo down pat."

Twenty-one years have passed since Lyn moved away from Delaware. She has never gone to another teacher, never taken another class. "If I lived within two hours of Ed Loper," she told me, "I'd be there."

She did visit Ed's retrospective at the Delaware Art Museum in February 1996. She went home and cried for what she had lost. But she also went home with a renewed drive to paint. During the summer of 1997, she made a painting in Sea Isle City, New Jersey, of a pink house on the bay, and the owner bought it. This first sale "legitimized" her work, she told me.

She became something of a celebrity in this quiet coastal town of Sea Isle City. Her husband's brother, William James Young, called Terry, and his wife Judy own two local bars: The Dead Dog Saloon, so named because the property on which they built the bar had been the burial ground of the former owner's dead dog; and Shenanigans, the adjoining bar, where a primarily younger crowd congregates to listen to live rock music. Terry told her everyone in the Dead Dog Saloon talked about the "woman painting the pink house," commenting on her progress and exploring

the "strange way she worked on that geometric grid of color." Judy said it was the best free advertising they had.

Today, Lyn feels so confident she is willing to tell colleagues she paints. But in conservative Rochester, New York, most people she knows seem shocked when they see her pictures. "They see me as a fifty-year-old stodgy math teacher," she said. "They expect pretty pictures of flowers in a vase. And I show them semi-abstract pictures with fractured light and distorted subjects. They look at the pictures and look at me and say, 'You're a math teacher.' They don't know what to make of it."

Ed's youngest student in 1997, twenty-three-year-old Alisa Colley, started attending his class during the summer of 1994. The daughter of Nancy Colley, a thirty-year student, Alisa had grown up hearing about Ed and seeing the work her mother did. When she was five years old, she went to Quebec City with her family so her mother could work in Ed's class. She thought Ed a "grumpy, scary old man."

When she was twenty years old and a junior at the University of Delaware working toward a BFA in photography, she decided to join Ed's class because she "might move away from Wilmington and he might not be around for much longer."

I was in the Thursday afternoon class Alisa attended in the spring of 1994. Ed called her "Sugar." She had youth and beauty on her side.

Ed remained pleased with Alisa's work until she went to Quebec City during the summer of 1996.

"He was not happy with the extent I was distorting things," she told me on a warm October afternoon as we sat on my deck talking.

A passerby heard Ed yelling at her, and he stopped to listen. Then he looked more closely at Alisa's picture, and he told her he wanted to buy it. After she finished it at home, she sold it to him for $250.

Alisa feels grateful for her experience with Ed. "A lot of people my age are interested in the statement rather than the visual qualities of things," she told me. "Ed taught me to forget the objects and go for the quality." When it comes to painting, therefore, she has no interest in political, social, or religious issues. She looks for angles, drama, and massiveness.

When she found herself in Cape Cod during the 1997 summer, working for a low-budget, independent film as a loader (the person who loads the film, keeps up the inventory and all the paper work, and assists everyone else in the camera department), she looked for painting subjects on her days off.

She found the beaches too open and too horizontal with nothing to break up the monotony. In Provincetown, the press of tourists felt burdensome. So she drove around and looked and looked. She finally passed a gas station on Route 6 near Truro, and she liked it. After she set up her easel, she noticed a small sign above the window, "Edward Hopper Video Sold Here." She figured the first name

must have been a mistake and should have read Dennis instead. But an employee of the gas station set her straight. He came over to see what she was doing and told her, "Everyone paints this gas station, because Edward Hopper painted it. But no one ever painted it like you."

Like American painter Edward Hopper, Alisa is attracted to commonplace scenes other artists ignore. While she admits she likes the stark quality of Hopper's *Gas*, painted in 1940, Alisa's color is richer and more vivid, and her gas station fills the canvas and says "big." Her distortions, an elongated, twisted, and bent gas station with a huge sign looming over it, all accentuated with heavy black line, are more a cross between Soutine, Modigliani, and Picasso.

She now says she must go it alone, to learn how to finish her pictures without help.

Long before her, other students also came to that decision.

Ruth Anne Crawford, a well-known Wilmington artist, began studying with Ed when a neighbor, Peggy Shirk, urged her to join his class at the Delaware Art Museum. Ruth Anne had studied at Moore School of Art in Philadelphia and, at that time, was enrolled in Will Barnett's class at the Delaware Art Museum.

She liked Ed from the start, finding him honest with himself and with students. He saw the world as more meaningful than most people, and he knew how to show her that extra meaning.

He also made her "madder than hell." Once he found out she had attended an art school, he started attacking her: "They don't teach anything worthwhile in art school," he would say. "They ruined you for painting."

Ruth Anne would reply, "Just leave me alone and let me paint."

For more than twenty years, Ruth Anne told me, Ed spoke a language she could understand; he was full of information, and he encouraged her to begin teaching and to show and sell her work. Soon Ed also painted in Ruth Anne's studio on Thursday mornings, and they developed a solid, deep friendship which endured conflicts and outright fights, many of which occurred in Ed's studio during class.

I heard him say to her, "When are you going to do what I've asked you to do?"

I heard him say to her, "I say the same thing over and over again, and you never hear it."

And I heard him say to her, "I've wasted thirty years teaching you. You have not learned anything I teach."

That last remark did it. Ruth Anne stopped attending Ed's classes in 1988, and although they remain good friends, she does not want him telling her how to paint her pictures. "My work tends toward the illustrative," Ruth Anne admitted. "Ed hates that."

Most students acknowledge they continue to study with Ed because he believes in them. He may be difficult, persistent, and insistent, but he also tells

them they will "get it" if they keep working. He tells them that's how he learned.

Michelle Spellman is no exception. Even though Ed was the first person to make her cry in fifteen years, she does not doubt she made the right decision to study with him.

"When I saw his retrospective," she told me one afternoon during the Thursday class we attend together, "I knew I had something missing in my life as an artist. And I knew he would be the one to help me find out what it was. It was absolutely the right decision. From the day I first came here, I saw differently. Everything I thought I knew seems questionable. In my house, it is like I have on a new pair of glasses. I see colors everywhere. I think about where I put a plant. My friends think I'm crazy, but I know I'm in the right place."

Students trust him. And once they become his disciples, he tells them they are obligated to keep painting. Otherwise they have wasted his time. He does not understand "comfortable hobby."

Ed tackles the making of pictures with passion, as though his life and the lives of his students hang in the balance: He pounces on wrong color relationships, missed lines, or clumsy compositions like a cat on prey. "Too light," he'll shout from across the room during a class, and each student freezes, every eye focused on the last color applied, brushes suspended in air, the room filled with collective guilt. "You know who I'm talking to," he'll laugh, "you know who you are." Then he'll finally say a name

and go to that student to explain his reasoning. "Fix it now, *please,*" Ed tells the student, with the emphasis on please. It is a demand, not a request.

Ed teaches hard work. According to Eric Booth, "The *work* of art is any process of becoming concentric with some inherent truth and pulling things into some order; it is the process of pulling truth around a personal nucleus."[4] Ed shows students how to do this.

I do not understate the difficulty of this learning by adding that Ed's classes also are fun. The conversation ranges from politics to sex to religion. No topic is off limits. Ed loves to argue. No matter if his ideas come from Oprah Winfrey or *Good Morning America*, he comes to each class ready with bait.

"What do you think about that poor man, Air Force General Joseph Ralston, out of the running for head of the Joint Chiefs of Staff, because he had an affair?" he'll ask, laughing. "That's what men do."

The fight is on. I try to convince Ed that adultery causes pain, that it is a betrayal of vows. He tells me men can't help themselves; it is the way they are made. They can't be monogamous; it is contrary to their natures.

"It's about sex," he says, "not love."

I tell him he is crazy. Men just feel they have permission to be led by their desires. Women simply make a choice and live with it.

He tells me I am naive.

I quote Ellen Goodman, a syndicated columnist I read regularly in the *News Journal*. I tell him she

wrote a column titled: "Rush to judgment is the military's undoing." She said, "In the issue of consensual sex, a touchy, uncertain, fluid majority is once again leaning toward the side that says, 'It depends.'" I feel proud of myself that I can remember her exact words.

"Yes," Ed agrees. "It depends."

And so it goes, with the women in the class generally lining up against him. The few men do not usually get into it, unless Ed asks them a direct question.

While the argument rages, Ed continues to go from student to student correcting a color relationship, criticizing a drawing. God help the student who does not do what he says. While most attacks are not brutal, even subtle ones can sabotage confidence.

For example, before I left for a painting trip to Gloucester, Massachusetts, in August 1997, my husband Don and I joined Ed and Janet for dinner. As we talked in their living room, Ed reminded me "not to let the objects intrude" while I worked in Gloucester. He got out his Cézanne book and showed me how few details Cézanne used, how Cézanne's pigment simply defined trees and buildings with short hatch-like strokes, and "this was all that was necessary."

Then he showed me how he made his own pictures, how he did not even look at the objects, but just smeared colors, one next to another, until the canvas was covered. He covered a 30 by 40 inch canvas in a mere three mornings of work.

"You work too hard," he told me. "You don't need to do that."

Janet tried to intervene by telling him, "Ed, she may not like the same things you like." Good try, I thought, but nothing stops him.

It's as if the man has a permeable membrane thinly separating his ego from everyone else's. If students do not protect their fragile individuality, his words slip in, poking, prodding, even attacking: "You let the objects intrude too much; that's terrible painting; that's pure stupid; that color is unfair."

Ed rarely surrenders.

I wondered why he perceives every divergence, every step taken down a different path, as a hit to the central pole which holds up the tent of his aesthetic convictions. It seems he cannot let that happen because he spent his lifetime erecting that tent.

When I asked him this, he shrugged the question away. "I mean to be the best teacher I can be," he told me. "I stop telling students what to do when I see them doing something I could not think of doing—or that I can't do. It's that simple. I have a mission. And I'm glad to see them get so good."

When his students become artists, therefore, it makes him happy.

Artisthood—

I became an artist during an Ed Loper class excursion to Quebec City.

I had traveled to Boothbay Harbor, Maine, and Provincetown, Massachusetts, to attend his outdoor painting classes before I tackled Quebec. In both cases, I combined a family vacation with the two-week painting class. In both cases, my children and husband did fine on their own in the mornings, freeing me for my four-hour session. I then joined them for afternoons of swimming, hiking, boating, and general fun.

This worked out quite well, so I invited my mother to accompany us to Quebec City. However, I had been attending Ed's classes for nine years, and I fell in love with Quebec City. This time, all I wanted to do was paint.

Quebec City was a sensory feast. French filled the air with musical tones. The breeze carried the aromas of stews, soups, rich sugar pie, and pastries. Toward evening, from our campground, the city appeared across the river like carved jewels on a crown. The bridge to the Island of Orleans resembled a string of pearls.

In the streets where I made my pictures, the cracks in the stone buildings became distinct linear patterns, with bold color contrasts of roofs, shutters, and doors screaming for expression. The awkwardly placed crowded buildings just about told me how to arrange them on a canvas.

The streets talked to me of massive shapes, placed at odd angles. Cadmium red, viridian, ultramarine roofs were side by side, topping facades of brightly shuttered white stone gleaming in the clear light. The Château Frontenac, the large hotel erected by the Canadian Pacific railway, loomed over the city like a huge medieval castle, green and gold spires catching the sun and set off against the cerulean blue sky.

The streets were narrow, sharply steep, accentuating the looming feel of the buildings. I delighted in details: flags flew everywhere. In 1976, the Canadian flag, the red maple leaf on white background bordered by red, flew next to the Quebec province flag, a white cross separating four areas of ultramarine blue, each containing a white fleur-de-lys. The windows each flew a small flag; larger ones were stretched across the major streets.

This combination of bold color contrasts and dramatic interrelationships of variously shaped buildings beckoned me. Like Alice in Wonderland, I saw the city wearing a label: Paint Me. So I did.

That was all I did. I started at 9:00 a.m. and forgot to stop. My mother got annoyed. It rained, and I kept painting. She fumed. I stood so long in the cold, my hands and feet lost feeling. She screamed at me. "What kind of vacation is this?" she asked. "How can you work so hard at a hobby?" I did not have an answer.

One afternoon, she confronted Ed in the park. I was involved with a building across the street, and she watched him tell me to darken a section of the road.

"Why does she need you?" she asked him.

He told her he could speed my progress. He

wished someone had done that for him.

She accepted that answer, but still gave me hell for not quitting sooner so we could go sightseeing.

Later that week, as I worked on a painting using sharply descending steps with a red awning jutting out the right side, setting off black iron railings with curved street lamps, Ed sat on a bench behind me. A tourist came by and asked if he would look at a painting she had just purchased.

She unwrapped it and showed it to him. He asked her if she wanted a souvenir or a work of art. She said she wanted something to remind her of how beautiful she found Quebec. "Then you got what you paid for," he said. "That's a work of art, what she's doing," he said, pointing to my picture. "But you got a bargain of a souvenir."

"That's a work of art," I heard him say.

"Am I an artist, then?" I wondered.

What I did know is that I had color shapes swimming in my head when I closed my eyes to go to sleep at night. I awoke at three in the morning to plan the picture I wanted to paint and could not wait for daybreak so I could get to it. And during the long car trip home, the landscape flew by as fragments of color, as if I saw it through a kaleidoscopic lens.

Once home, I went back to my daily routine, car-pooling kids to swim meets and Little League games, grocery shopping, and, of course, cleaning. As I dragged the vacuum from the closet, plugged it in, and started to clean the carpet, I burst into tears. If I could have designed one of those bumper stick-ers which became so popular in the 1980s, mine would have read, "I'd Rather Be Painting." Making pictures had become more engrossing than making beds.

The following year, I used that Quebec painting in a seminar talk at the Barnes Foundation, a school for art appreciation in Merion, Pennsylvania. After completing the first two years of study, students attend the seminar to try their hands at applying the objective method to a subject that interests them.

I called my talk *Education by Painting: An Analysis of the Expressive Process*. In it, I compared my Quebec picture to two others also painted by Ed Loper students, and I explained the differences.

When Miss Violette de Mazia, the founder of the school's teaching method, introduced me as an "artist-painter," a term she did not use indiscriminately, my mind drifted into a tiny space of suspended time. In it, I saw my painting hanging next to Pascin's *Seated Figure* on the right wall of the seminar room. It looked good there.

If I were an artist, I imagined, I could join all those other artists who had lived before me in artists' heaven, that studio in the sky where artists go when, as Hamlet says, they "shuffle off this mortal coil." I saw myself passing by the open door to this celestial chamber, and, when I looked inside, I saw Titian, Cézanne, Rouault, Renoir, and Georgia O'Keeffe sitting around a big table talking and drinking wine.

"Come in," they all called to me. "Join the conversation." That's what being an artist means. It means I am ready to join the conversation.

I never heard the rest of Miss de Mazia's introduction, but I slipped back to reality as she announced the topic of my talk. As I started speaking, I knew my life had changed: I felt welcome to join in the conversations of all artists, living and dead, and add my contribution, my pictures, to all of theirs; I also now knew what I had been calling my hobby actually was my work.

"There are levels of achievement lower than the loftiest," Violette de Mazia told us.

To this day, I remain encouraged by that thought, too. Artists do not have to make huge contributions, like Giotto, for instance, to join in the conversation. Small contributions qualify.

To become an artist, Ed constructed his own path and walked it. He then tirelessly brought me, as well as many other students, to the trailhead marked "Artisthood."

Some of us took the hike.

The Vision

My Teachers

Before I met Edward L. Loper, Sr., I thought I could see.

As a child, seeing meant taking in my surroundings, the seven- to twelve-story apartment buildings called Parkchester, an innovative city-within-a-city in the Bronx, New York, developed by Metropolitan Life Insurance Company to house working-class people after World War II.

It meant seeing those gray, barren city streets come alive in the spring and summer, green leaves bursting out of bare branches, turning the skeletal twisted limbs of the trees into round soft pillows, thick and lush and, if I had words for it then, Renoir-like in their voluptuousness. I could see the trees when I looked down from my seventh-story living room window and called my brother to come in for supper.

But I did not have words for it then. I did not even see those trees as I just described them, then. I see them now, looking back, after Ed Loper got to me.

This is what I mean by seeing. Most of the time, we don't see. It takes artists to teach us how, and those artists have to have certain things happen to them so they can make pictures which teach us to see.

I had Mary Spasik, Irving Pines, Ed Loper, and Violette de Mazia happen to me.

When I was eight years old, I begged my mother to find someone who could teach me to make pictures and paint with real paint, not just the poster paint we used in school. I liked to draw and color with crayons, and somehow I got the idea there might be more to it than that.

Mary Spasik lived near me. Along with her own five children squeezed into a two-bedroom apartment, she took in and taught neighbors' kids to draw and paint. After school, I walked the short distance to her building, took the elevator to the fifth floor, and entered her "dining room," the small entryway adjacent to the kitchen. There she sat us at a table covered with newspaper. Later, she removed the newspaper and covered the table with oilcloth for dinner. The apartment smelled of turpentine, linseed oil, and garlic, especially if she had spaghetti sauce cooking on the stove.

Mrs. Spasik showed me how to copy magazine, postcard, and calendar pictures. I chose a snow

scene as my first subject, a lovely landscape consisting of a frozen stream curling through blue-lavender snow with evergreen trees dotting the horizon. I learned to draw it, mix colors with oil paint, keep my brush clean, and produce a pretty good resemblance, if I did think so myself. I especially loved that snow. I loved how that brook looked frozen. Like the song in *Afternoon in the Park with George,* I felt thrilled: "Look," I wanted to say, "I made a stream where there was no stream before."

But I was quiet and shy, and I did not say a word to anyone.

Throughout the making of the picture, Mary Spasik told me I learned quickly and did good work, and she wished I would think about joining her contest: She gave points for finished pictures, and the child with the most points at the end of each month won a prize, a brush or tube of paint or small canvas board.

I said no.

While I could not explain it to her, something in me bristled at the idea of her judging my work against everyone else's. She thought me stubborn, I'm sure, and since I was an acquiescent child, eager to please, my refusal surprises me even today.

When my mother arrived to pick me up, I showed her this picture. She made all the usual comments when I showed her anything I made, from the thick sticky valentines oozing paste to my drawings of straw huts for my Belgian Congo report: "You made that?" "Oh, it's lovely," and so on.

Mary Spasik then came up to us and said to my mother, "She'll get better."

There we stood in the cramped dining room, the newspaper rapidly giving way to the oilcloth, and my Eden ended at that moment. "She'll get better." I had been a child who had just made magic happen on a canvas board. What could anyone else know about how that felt, I wondered. It took twenty more years for me to find out.

I stayed with Mary Spasik until I could travel on the subways alone. Then, at thirteen, I studied at the Albert Pels School of Art, a loft in the West 70s with real easels, skylights, and models. By now, I could copy anything, and my framed paintings of ballet dancers, clowns, and autumn, winter, spring, and summer landscapes decorated our apartment.

I might have continued down this path except for two events.

One I only remember because it began an itch that I did not know how to scratch. One Saturday afternoon, I stopped at a friend's apartment on my way home from the Pels School, carrying the painting of a clown I had just finished. I had made a portrait, complete with red nose and sad eyes. I felt particularly proud of the sparkle in the eyes, a technique which received great praise from my teacher. "So lifelike," he had said.

Irving Pines, my friend's father, purchased paintings made by "real" artists. So I decided he knew something about pictures and, when he answered the door that day, I was glad to show him

my most recent piece.

He spent several minutes looking at it. Then he said he thought it showed considerable skill, but he didn't see me in it.

Me in it? What did that mean? I had been taught painting had everything to do with skill. No one ever told me anything about personal expressiveness.

Frustrated by my own attempts to make pictures and bewildered by the work of artists I saw in museums, I gave up trying to make sense of it.

I told myself I had spent too many Saturday afternoons in the Museum of Modern Art, a haunt I inhabited mostly to get warm after ice skating in Central Park. My friend Susan Pines would read the labels out loud while I tried to fit the titles to the pictures.

One day we came upon Yves Tanguy's *Mama, Papa is Wounded.* We giggled as we attempted to pick out Mama and Papa in that weird landscape of prickly objects. "Could that be Papa in need of a shave," I said, and we laughed so much a guard asked us to leave.

As you can tell, I had not taken art appreciation courses in high school. Later, at Queens College, I endured the lights-out slide shows called art history. I hated the memorization of dates and styles, and I received one of my only C's for my lack of effort.

I suspected there were good reasons to go to museums and getting warm was not one of them.

So, at twenty-three, when I tackled the Louvre, I prepared.

I read everything I could find about the *Mona Lisa.* I found out it was a masterpiece, perhaps the greatest painting ever painted. I enjoyed Walter Pater's gushing accolade: "This beauty, into which the soul with all its maladies had passed." I learned the model, Lisa, was the third wife of a Florentine merchant named Francesco di Bartolommeo del Giocondo, the accepted knowledge in the 1960s, that she was twenty-four, and that, as a portrait, the work was, in Vasari's words, "an exact copy of nature." I discovered Leonardo had laid down on the panel approximately a hundred thin glazes.

Yet, with all this preparation, my firsthand encounter with the *Mona Lisa* provided little enrichment. I found it very small, encased in bulletproof glass, surrounded by hordes of tourists like myself, and very uninteresting. I felt something must be missing in me: When aesthetic sensitivity was handed out, I figured, I must have been ice skating.

This sense of aesthetic inadequacy stayed with me until I moved to Wilmington, Delaware. After college, graduate school, and a two-year stay in Davis, California, where I taught English at the University of California and wrote for the *Davis Enterprise,* the local newspaper, my husband and I moved east so he could work for DuPont. Once settled, I became Ed Loper's painting student.

I met Ed quite by accident when I went to the Delaware Art Museum to sign up for a painting class

in the Art Center. My doctor, trying to assist my inability to conceive a child, told me I should relax. "Take up a hobby," he advised.

I decided to pursue painting again, and since I arrived at the museum at the end of the registration period, all classes in the Art Center had been filled except Ed's.

I met an imposing black man who looked at me intently but asked no questions. He did not smile. He did not introduce students to one another. After everyone arrived, he simply put us to work.

At that moment I had no way of knowing how much this accident would change my life.

I did not know until much later, when I started to interview Ed for this book, what had happened to him that enabled him to teach the students in that class to see colors that did not seem to be there at all.

Ed's Teachers

Edward L. Loper, Sr., had Miss Jefferson, Bill Burton, Ralph Loper, N.C. Wyeth, the WPA, Henry Henchy, Horace Pippin, Max Weber, Albert Barnes, and Violette de Mazia happen to him.

The only child of Marian Loper and William Stewart, Ed grew up on Heald Street in Wilmington in a neighborhood called "over 11th Street Bridge." The 11th Street Bridge—authorized by the Legislature on March 20, 1867, the same year it authorized the construction of a drawbridge over the Christina River near Third Street because of the number of manufacturing plants operating east of the Brandywine and Christina Rivers—was a swing bridge mounted on a turntable in the middle of the Brandywine River.[5] The 11th Street Bridge dominated Ed's childhood; only a few blocks from his home, he spent hours watching it, waiting for it to swing open so boats could pass. It did not open often.

Although the homes in this section of Wilmington were evenly divided among black, Polish, Swedish, and Italian families and although on the surface the relationships were friendly, street fights were as endemic to Heald Street as the frogs in the nearby marshes, for which the area got the nickname "Frog Town."

Ed's mother gave birth to him at home, 1015 East 13th Street, a small two-story row house which she shared with her mother, stepfather, brother, and stepsisters and stepbrothers. Like the other brick houses in the neighborhood, it had three wooden steps leading to an arched doorway. Wood-framed windows faced the brick-paved sidewalk which rose a foot above 13th Street's ash-packed dirt road.[6] Open fields, wood yards, and small gardens surrounded the area.

One of Ed's earliest memories is playing under a tree in front of this house. His grandparents poured sand where the tree roots pushed out the sidewalk bricks. In this sandbox, Ed used sticks to build a mini playground. He built swings, a see-

Over Eleventh Street Bridge. Drawing from memory by Edward L. Loper, Jr.

saw, and a slide. A neighborhood magician, Sam Johnson, so called because he did magic tricks for the children on the street or for the congregation in the church, walked by. In church, Ed had watched Sam fill six to eight glasses with water and drink them. Then he would pull his ear and water would pour out.

Sam could also throw his voice. Sam performed his most notorious ventriloquism at a funeral. As the men lowered the straps holding the coffin, they heard a voice from the coffin say "Lower me down easy, boys." They dropped the coffin, and Sam Johnson was arrested. "During the night," Ed said, "Sam made mice scream and holler all over the place, and they kicked him out of the jail."

This day, Sam Johnson laid his hands on Ed's head and declared: "This little boy will be a great man someday."

Ed was four years old.

"What a dramatic moment," I exclaimed. "Have you remembered it all your life?"

"No," he answered me, laughing. "When I was twenty-five or so, I remembered it, about the time I started winning prizes and selling my work. People began asking me when I knew I would be an artist, that kind of thing, and it came back to me."

Other experiences also came back to him.

When it was raining, he would lie down in front of the open door of his house and look at the brick pavement on the other side of the street. He saw rain hit the pavement, make bubbles, and then watched those bubbles float on the river of water running down the dirt street below. "I could do this for hours," he said. "I had no words for it. I thought it was pretty."

His mother decided he should have piano lessons and sent him to Miss Henrietta Gray, a neighbor two doors away. She had a player piano, and she tried to teach him to read music and learn scales.

"I couldn't do it," he told me.

Ed figures he must have been "drawing stuff," because his stepfather, Reese Columbus Scott, told his mother, "Marian, that boy doesn't want to be a piano player. He likes art."

He attended Public School 29 at 12th and Poplar Streets, a primary school for black children. He walked across the 11th Street Bridge to Church Street and then on to North Pine Street where, like Heald Street, row houses lined both sides of the street. He walked through Kirkwood Park to his school. (The school was demolished when the addition to Howard High School was built. A parking lot for the Howard Career Center—a regional vocational high school which opened in 1975 and is connected to the 1928 building by an enclosed walkway high above the ground—now occupies its space.) Ed's grandmother's girlfriend lived across the street from the school, and Ed knew she looked out her window to see him pass by. "I couldn't get away with anything with her watching for me," he told me.

He has fond memories of Miss Jefferson, his art teacher. She pushed her cart, filled with art supplies,

into his classroom. Ed said she was a beautiful thing: young, maybe twenty, long hair pulled back, thin, small waisted, not square shaped like most of the other women teachers. He fell in love with her and worked very hard to learn to draw so she would like him. "She broke my heart when she got married," he said.

Using show-card color on poster board, Ed did a painting of ducks in a pond which he gave to his Aunt Ethel.

But when Miss Jefferson held a contest, asking her students to illustrate the theme "The Beauty of the Country Are the Flowers. May They Always Be," Bill Burton won the prize. To this day, Ed believes his own picture was "prettier."

Although he learned to use crayon, show-card color, and gouache (opaque water color), his most important lesson derived from losing the contest to Bill Burton: He learned to push himself to get recognition.

At the same time, his mother's brother Ralph had been writing his sister letters, illustrating them with drawings of things he had seen and done. Ed remembers one of a Chinese junk and another of a Japanese pavilion. What he remembers most was his mother's bragging to him about her brother. "What a wonderful thing, he can draw like that," she would say. "She thought he was God's gift," he said, and he felt jealous again.

At age ten or eleven, Ed would sail his kite two blocks away in the city dump where Northeast Bou-

levard now runs. He would climb over a fence, go across Thatcher Street, and run to the open field. The dump contained ashes and piles of mud brought there from construction sites. One day, he took a big hunk of that clay and carved the head of Benjamin Franklin. He liked doing it.

When he was twelve years old, he watched sign painters draw and paint a hand holding a cigarette on the signboard facing the railroad tracks at 12th and Railroad Streets. He marveled at how "real" the hand looked. "I thought they were doing magic," he told me.

When Ed was about fifteen years old, his Uncle Ralph brought back to Wilmington a *real* oil painting of a cowboy on a horse. Ed's mother loved that picture, and Ed wanted to be able to "paint that well."

"Sounds like pretty women and jealousy were your motivations," I told him.

"Yes, that's a lot of it," he agreed.

While he attended Howard High School, he continued to try to learn to draw and paint. However, he did not receive the instruction he craved. Instead, he learned marbleizing from his art teacher, Oscar Carrington, a process of pouring paint on water and pulling prints. "It was worthless," Ed said. "I wanted to learn how to draw really well."

He taught himself.

As a school hall monitor, Ed sat at a table outside the art room and next to the staircase doors leading to the second-floor hall. His job was to take stu-

dents' names if they were out of class. Most of the time he had nothing to do, so he examined the perspective of the hall, the way the ceiling tiles slanted diagonally and converged at the rectangular window at the end of the hall. He drew the inset metal lockers and the doors, measuring the angles and lining up a ruler on the edge of a vertical pad to see which way the lines went.

He also looked at movie magazines and copied the pictures. His friend, Herman Pugh, got so good at doing this he got a job making the signboard advertisements for the Hopkins Theatre on French Street in Wilmington. His other friend, Weyman Frazier, did the lettering. Ed envied Pugh's skill but found copying pictures boring. He also hated that Pugh received the "School Artist" award at graduation.

He did enjoy drafting, taught by George Whitten, his shop teacher. "We had to do exact drawings of the things we would make," he said. "I even thought I might be an architect, but I knew there was no such thing for a black boy."

He continued to look in books and at calendars and tried to figure out how to make pictures like the ones he was seeing. His grandmother's sister, his Great Aunt Bertha, had a Civil War book, and Ed remembers studying the pictures of battles and loving how "good they could draw."

His grandmother, a housekeeper for Mr. Charles Hoopes (an executive for Atlas Explosives which later became Hercules Inc.), brought home N.C.

Wyeth calendars Mr. Hoopes gave her. Ed marveled at the skill exhibited in *The Alchemist* and the Indian woman leading Lewis and Clark.

Then one day he came home to see his mother sitting by the window and he exclaimed, "Mom, you're green!"

"That's the first time I saw pure color," he said. "I didn't see her at all."

The blue light coming in the north-facing window made her brown skin look green. His itch started here.

But he did not know how to scratch it.

Instead he painted a picture of a chicken sitting on a fence post. He painted it on a window shade. "I thought that was real canvas," he said. "I had no idea what canvas was."

After high school, he hunted jobs, not colors. He had received a sports scholarship to Lincoln University. But in 1934, he had three children to support, and his grandmother said "no relief," the word she used for the various uncoordinated agencies of the state and local governments charged with welfare activities in Wilmington during the late 1920s and before Franklin D. Roosevelt's "New Deal" in 1933.

"Why didn't you go to Lincoln and try to work also? Couldn't you have sent some money back home?" I asked him.

"We learned to help each other. I was taught to do that. They weren't going to do too well without me. I felt responsible. It's hard to describe to people

who weren't around in those days how bad it was," he told me. "I would walk the six miles to Bellevue where DuPont was building a new pigment plant." There he would wait with 200 other men, and after three men were hired for the day, the rest of them would walk home again.

One day "old man DiSabatino," a local building contractor, hired Ed to wheel bricks up to the elevator which brought them up to the scaffold for the bricklayers. Ed, believing that when you work for someone, you work hard, figured a way to get the job done efficiently. He took the bricks off the pile and put them in the wheelbarrow. Rather than just do one at a time, he hunted all the empty wheelbarrows he could find, filled them up, and lined them up at the elevator. As an empty one came down, he merely had to roll the next one in. He thought he was being inventive, but his boss saw him loafing and fired him.

His next job was unloading cement from a freight train. He did it very slowly, but steadily. The other workers coached him on how to do the job: work only enough so they can see you working. Otherwise, they warned him, he would work them out of a job.

Sometimes when his wife, Vi, was working as a housekeeper, he would wait for his daughter, Jean, to wake up. After he fed and dressed her, and put her in a carriage so she would go back to sleep, he would wheel her to the city dump, and he would pick coal.

People dumped the ashes left from their coal fires there. He took a rake and picked through the ashes to find tiny lumps of coal he could take home to heat his house.

"Did you still want to paint?" I asked.

"I thought about it all the time," he said. "Especially during Art Week."

During Art Week, all the stores on Market Street, the hub of downtown Wilmington, displayed paintings in their windows. At Miller Brothers Furniture and Van Sciver's Furniture stores, Ed saw N.C. Wyeth paintings, and these "real" pictures by this well-known illustrator thrilled him. He dismissed most everything else he saw, deciding he "could draw as well as the others," but when he saw the N.C. Wyeth's "with the birds and those guys shoveling fish out of the bottom of that boat," he got excited.

He had seen reproductions of N.C.'s work in the calendars his grandmother brought home. He had looked forward to each year's new collection of pictures. Still, when he saw these real paintings, "I flipped," he said. "I just went crazy. They were the most wonderful things I had ever seen in my whole life."

"How did you reconcile these two worlds?" I asked him. "What kept you going?"

"Survival," he told me. "But I was going bad. The jobs I could get convinced me if I worked hard at that stuff I'd never get anywhere. So I started gambling. My grandmother's boyfriend, Mr. Naylor,

showed me how to cheat. He said I could be a great gambler, but I had a temper, and gamblers can't get angry. If a gambler gets caught cheating, he has to smile and laugh. He warned me not to get defensive and get myself in fights.

He showed me how to shave the corners off dice so they would roll off the side. This gave me a little edge. He showed me how to shake dice in the palm of my hand, but throw the other pair held further back. He also used a hand drill to drill through certain numbers on the dice. He filled the holes with mercury from a thermometer. Then he would pack the shaved pieces over the mercury, smooth it over and paint it, and no one could see what he had done. I knew which way the dice would roll, and, after a few hours, I would win. He showed me how to deal cards from the bottom of the deck, and I would deal myself two aces and no one noticed. Actually, I was so young, the men thought I didn't know anything, so they weren't watching me, they were watching each other."

"You would have become a con man?"

"Yes," he said, "or something else illegal. I saw the futility of the kinds of 'honest' jobs available to me."

Then he got lucky.

Vi applied for relief. While she waited in line at City Hall, someone mentioned that the Delaware Division of the WPA was hiring artists. "My husband can draw," Vi said, and she was told to send him to see Jeannette Eckman.

Vi's accidental encounter mated Ed's ambition with the opportunity of his life.

Ed went to a large house at 14th and Market Streets and met an elegant woman, "blue blood, hair perfect, dress perfect, talk perfect," is how he described her. Jeannette Eckman, a lifelong resident of Delaware, is best known for having edited the book, *Delaware: A Guide to the First State*, which was written by the WPA Writers Project.[7]

She was in charge of the Federal Arts Project with David Reyam, supervising the artists' section in which, ultimately, some thirty Delaware artists participated.

Ed told her he could draw, and she hired him for training with the Index of American Design, a federally funded work program to record American objects in decorative arts and design that had not been documented and were in danger of being lost. The objects were rendered in a realistic, detailed style in both color and black and white.

Ed knew the three people hired before him: Earnest Towers, Towers' uncle, and Weyman Frazier, his high school buddy. Weyman Frazier, "a black guy, a cool, smooth-looking guy," Ed said, still used his lettering skill as a sign painter. He knew they did not know any more than he did.

The old three-story home at 14th and Market Streets became Ed's art school. David Reyam started showing the four men how to render values, shading from light to dark. Then Russell Parr, the man in charge of the Index project on the East Coast, came

up from Washington, D.C. He hired more men with art school backgrounds, such as Gordon Salter and Sam Fineman, and slowly the "experienced" artists helped teach them how to render in watercolor exact reproductions of early American objects.

The entire project produced 20,000 Index plates during six years of operation, 113 of them by Edward L. Loper, Sr. The renderings are now housed at the National Gallery of Art in Washington, D.C.[8]

Ed had an honest job he valued. He worked from 9:00 a.m. to 1:30 p.m. everyday and received a $39.20 paycheck every two weeks for his Index of American Design work. Later, when he moved to the Easel Division, he took home $43.80.

I wanted to know how he made the pictures. I had seen some of them at the Delaware Art Museum as part of his retrospective exhibit in February 1996, and I had seen others in *The Index of American Design,* a book I had purchased long before this to show to students in my own painting classes. My students always thought Ed's rendering of *Speaking Dog,* a mechanical toy bank, was a photograph of the bank. I had to convince them it was a watercolor by showing them the credit in the back of the book.[9]

So I read the Introduction written by Holger Cahill, national director of the Federal Art Project, who called the technique recommended in the Index manual a transparent watercolor method. First, the artists studied the object and made a light outline drawing. They then washed in the lighter passages of color and gradually worked up to the darkest passage. One wash might be applied directly over another after allowing the first wash to dry thoroughly, or a glaze (a mixture of mediums and transparent oil colors) might be applied and new washes of color laid in over the glaze. They eliminated highlights, shadows, and accidental reflections.

In Wilmington, Ed explained, they modified the process.

First, since most people did not want to loan their objects, David Reyam, along with Gordon Salter and Willard Stewart, a photographer, visited private homes and small museums and selected the objects to be recorded. Stewart would shoot detailed sections of an object and then a full view. They would also make notes about the color of the object and describe its situation.

The photographs, however, destroyed the perspective. To get the detail, the camera had to be in so close the image flattened. To restore the full three-dimensionality, Reyam showed the artists how to lay out the perspective with strings; then they redesigned the object.

In the beginning, Ed told me, the artists had no idea what they were doing. When he arrived, the men were trying to render a silver strainer made by Benjamin Franklin. They were told not to use black; they must do it in color. "But there was no way these fellahs could understand that color existed in silver," he said.

Gordon Salter, one of the trained artists, explained how to use color to render the object. He

Ed's rendering of *Speaking Dog,* one of the mechanical toy banks. Index of American Design © 1998
Board of Trustees, National Gallery of Art, Washington, D.C., 1935/1942.
Watercolor, pen and ink, and graphite on paperboard.

showed them the various shades of grays, blues, and lavenders they had not seen by pointing to a spot on the silver strainer and asking the men to mix the color they saw.

If the object could be seen nearby, they also went to see it. The Historical Society on Market Street, for instance, had an eight-foot-tall George Washington sculpture, and they went to study it. They studied firsthand the iron grille fences which lined Wilmington streets and the railings on the front steps of the houses and used the photographs of them as well.[10]

Ed told me he felt particularly proud of the railing pictures. He carefully studied the step railings he discovered on West Street, marveling at their intricate scrollwork. He would run his fingers along the hanging grape clusters to get a visceral feel for their design. He also studied the grille work bolted onto houses to cover cellar doors. They had decorations of little cupids in the corners, and he painted those.

They rendered George Washington statues and American Indian barbershop poles, or tobacco-store Indians, as they were called. And they rendered toys, dolls, and carriages, some Windsor chairs and Pennsylvania Dutch furniture.

The actual painting was slow and methodical.

Using very fine, crisp lines, Ed made a drawing on a thin sheet of paper. Then he traced it onto a plate, a thick piece of watercolor paper, on which he would paint.

To paint, he used watercolor and a very sharp pointed brush. He used one little touch of watercolor at a time. "If it was a maple-colored object, I'd wash a tint of yellow over all the front-facing surfaces. Then on the sides, the surfaces that were going back, I'd give them a slight wash of blue," he told me. "Then I'd start placing color on a little bit at a time, just wash it on, and cover the whole thing with a tan color. After it was totally dry, I'd take a #5 watercolor brush and work it until I had just a point, and I'd touch the picture with drops of colors, dab, dab, dab, all day long. Then I'd work to get the modeling, shade it from light to dark. Then I'd go in and start doing the scratches and the grain, working a little bit at a time doing each thing."

He continued until his picture looked exactly like the object's picture before him. Reyam never let anyone stop working until he felt satisfied the picture was perfect.

Ed told me he completed about two or three pictures a month.

The work challenged him, and he felt proud to hold his own with the artists in his group. Some of them had attended the Art Students League in New York City, a couple of them had been to the Pennsylvania Academy of the Fine Arts, a few had attended the Pennsylvania Museum School of Industrial Art, later called the Philadelphia College of Art and Design and now part of the University of the Arts.

Ed also felt intimidated by the erudite sophis-

tication of these men. They had been all over the world, and, when he first arrived, he did not know what they were talking about.

"The art-school men were so far ahead of me," he told me, "I asked myself, 'What am I going to do, be stupid all the time?' So I read and read and read. At least I would have some knowledge of what they were saying."

But knowledge did not equal social acceptance.

When the group had a party and went to a local restaurant, Ed could not go. In Wilmington in the thirties, black people did not go to white restaurants. "Of course, Mr. Reyam, who was nice but not very enlightened, would want to bring me some of the food," Ed told me. "He was an old man, and he couldn't conceive that I wouldn't appreciate this. I didn't want the food. I wanted to go with them. They did not even notice this was wrong. This was the way colored people had always been treated, so why not now."

"Didn't this make you angry?" I asked him.

"Sure it did. It still does when I think about it. I used to go fishing with a buddy, Abe Bell. His father owned Bell's Plumbing Supply. We'd go to Rehoboth, and he always stopped at the Smyrna Diner. I couldn't go in, so I sat outside and waited for him. I didn't want him to bring out any of that food either. I wouldn't eat it. I still get mad when I drive through Smyrna and think about it."

Ed did socialize with some of the other artists, including Walter Pyle, Eddie Grant, Gordon Salter, and Sam Fineman. They would go out and paint together and travel to Philadelphia for fun. He did not feel any discrimination from them.

And he could ask the many questions he had about art and hope to get some answers from these "experts," as he called them, "these men who had been to college and art school."

When he started to paint pictures after work, they told him what paint to buy and what to paint on. Instead of using window shades, they showed him how to stretch a canvas.

The atmosphere sparked his curiosity.

When the Index project moved to 10th and West Streets, to an Elks Home, people involved with the Writer's Project and the Music Project worked with them. The musicians practiced in the same room where Ed and his group did the Index paintings.

He did not mind. "When you're busy working, the music doesn't bother you," he told me.

"In fact, one fellow, Leon Devalenger, laid out maps of Delaware for Jeannette Eckman's history book in that same room," he said.

"Some of the fellows from the art department, like John Moll, did the illustrations."

Ed described the scratchboard technique John Moll used for these illustrations. He scratched with a steel pen through a watercolor wash into the soft chalk and wax surface of a prepared drawing paper. This gave the illustrations a woodcut-like appearance.[11]

As Ed grew more skillful and knowledgeable,

he gained confidence.

Russell Parr would stop by from time to time, bringing samples of work being done in other parts of the country. Ed was impressed with the quality of the work, especially from the southwest. "I was shocked how well people did that stuff," he told me. In the Massachusetts work, Parr showed them how textiles and blankets had every thread rendered accurately.

"I have a sneaking idea he took some of our metal work and showed it to people in other places," Ed said. "We tried to make our group, Delaware, one of the best in the country."

However, Sam Fineman kept insisting this was not art. He told Ed he had to get a style.

Ed did not know how to get a style, but he wanted one, whatever it was, so he could be a good artist. He became "style hungry."

Sam told him to study "real art," which was the art in museums he said. He also showed him a picture by John Steuart Curry on a *Life* magazine cover. *Tornado over Kansas*, painted in 1929, depicted a funnel cloud approaching as a family runs for the storm cellar.

Ed got excited. He decided to look at more paintings.

After work, he would stop at the Wilmington Public Library where the Howard Pyle Collection hung in a gallery above the main floor. The curator, Constance Moore, got so used to seeing Ed she knew him by name. Ed studied the Howard Pyle paint-

ings to learn Pyle's techniques. "Pyle created light flickering on the water around pirate ships," Ed said. "I began to see that light on the Delaware River and started using it in the pictures I painted after work."

He thought his morning work for the Index and his afternoon painting would make him an artist, but his new artist friends kept telling him otherwise. Even though he was making these accurate reproductions of objects, including every scratch, discoloration, or dent, this was not the work real artists did, they insisted, over and over again.

"I kept trying to figure out what painting was all about," he told me. "I had been warned by Sam Fineman the work we were doing for the WPA was copy work. Now he told me to go to the Philadelphia Museum of Art. I never would have gone there. I looked at Bruegel, Courbet, van Ruisdael and, to me, they looked alike. I also studied the El Greco's, and I liked those pictures."

He became such a familiar figure here as well, the guards would greet him and together they would talk about the pictures. Ed would get close to the paintings, put his nose on them, he told me, and then he and the guards would discuss the paint quality, the color, the atmosphere.

He fell "deeply in love" with Courbet's *The Spanish Woman*, a painting of a sensuous girl with long, black hair. "I don't know if I was in love with the painting or the girl," he told me, "but I studied that picture a lot and tried to learn from it what happened with the paint and how the paint was put on,

how he designed the picture, how he used the hair."

With Salomon van Ruysdael's pictures, he studied how the light "would be flickering on the edges of clouds and trees."

He also studied the work of American painters in *Life* magazine and liked how they painted late evening pictures. He started looking at the houses around the factory, the light on the telephone pole as it got dark, the muted, gray haze of late evening as the sun went down.

He used his cheap paints and canvas and went to work.

Jeannette Eckman bought one of these first paintings for $18. Ed went to Front Street and bought a coal cooking stove with a rack for a warming oven on the top.

These early pictures are somber. The paint is loosely applied in slabs of browns, tans, and dull yellows. And they have a swirl to them, probably an unconscious adaptation of the El Greco's he was studying in Philadelphia.

Ed felt quite proud of his work.

So much so, he used a Siemens' ad, an illustration of a boat laying cable in the Atlantic Ocean, as a subject. He loved the color of the rusty hull. He also used the wispy light shimmering on water that he was studying in the Howard Pyle paintings. He entered this picture into the 1936 annual Delaware artists' show.

One official said the Loper entry was "perfectly awful. Atrocious! A garish ship on a glassy ocean!"[12]

The judges rejected it.

"I don't think it was so bad," Ed told me. "That's what they said. They knew I did it, that's all. And in those days, blacks, Jews, Irish, or anyone low class had no chance with them."

Rejection did not daunt him. He kept painting, using the streets he knew so well as subjects and using as a studio any room in his house that was not being used by someone else.

Then, one night, as his grandmother cooked on the new stove, Ed looked out the back door across the open fields. He studied the Church Street Bridge (built in 1934 connecting 12th Street to Northeast Boulevard). He saw the reflections, the sparkling lights of the Hotel Darling and Hotel Du Pont, the darkness between the bridge and the hotels. He began to paint how the scene looked to him, because Sam Fineman told him worthwhile painting expressed how the artist saw the world.

In 1937, Ed sent this painting to the Wilmington Society of the Fine Arts for its Twenty-fourth Annual Delaware Show.

Ed got a telephone call that "knocked him out."

A jury of three eminent American artists had accepted *After a Shower*, awarded it honorable mention, a major prize, and also purchased it for the permanent collection. The jury had also admitted to the exhibit two more of Ed's paintings of gloomy Wilmington slum area scenes.

Vi did not believe it at first, Bill Frank wrote in a 1982 *News Journal* article.[13]

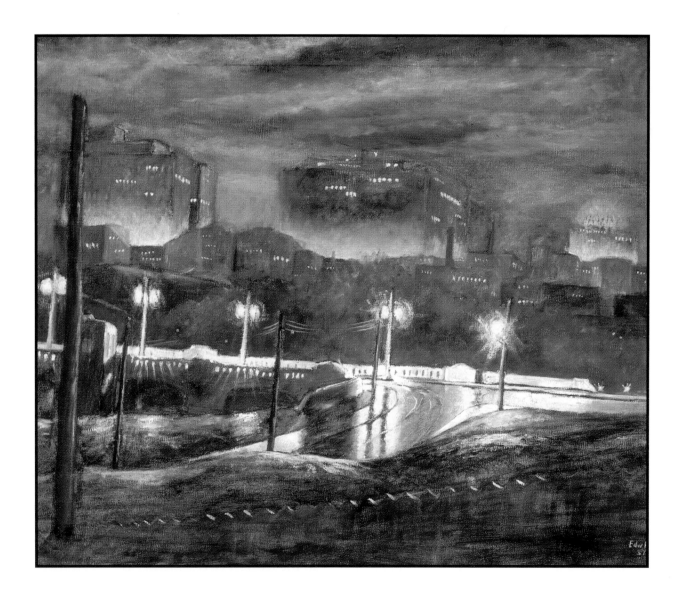

After a Shower, 1937. Oil on canvas; 21 ¼ x 26 ¾"; Delaware Art Museum;
Louisa du Pont Copeland Memorial Fund.

Ed told me he does not remember it that way.

All he knew at the time was that the newspaper ran a page or two of articles about the exhibit. He was told by his friends at the WPA that the best artists of Delaware submitted work. He knew the opening required dressing up. "I did not have the least idea of anything about it, about an art show, except that you send pictures," he told me. "The oil show in the fall and the watercolor show in the spring were Wilmington's big social things," he said. "I just figured I'd join the scene."

Ed remains convinced these judges did not know he was black. They found out he was black through the newspaper. "They were from New York and Philadelphia and did not have the least idea what was going on in Wilmington," he said.

Bill Frank and the other reporters for the *Wilmington Morning News* wondered if this black boy from Heald Street would go to the opening and what would happen if he did.

"I did not know not to go," Ed told me. "So when Walt Pyle suggested I go with him, I went."

The opening became an historic occasion. For the first time in Delaware, an African-American had a painting accepted into a Society show, and the painting was the first by a African-American artist to be purchased by the Society.

Moreover, the artist was the first African-American to attend a Society opening.

The opening reception would have humiliated someone less courageous. But Ed told me he thought it "wonderful."

He entered the entrance hall and looked through the open doors to the right and left of the hall into the large reception room.

"Everyone, except Walt Pyle and me, was there in tuxedos and gowns. I wore my work clothes, which was all I had," he told me.

After he went inside, Walter Pyle tried to introduce him to the other guests. "Some people refused to even look at me much less shake my hand. Their hands would almost go out, and suddenly they pulled them back to their sides. It didn't bother me because I wasn't used to shaking white folks' hands anyway," he said.

"Come on," I interrupted him, "it must have hurt."

"Oh, it bothered me, and Walt Pyle and I both said things under our breath, like 'sons of bitches,' things like that. I also whispered a phrase I learned from my mother's uncle, John Boob Loper, a piano player: 'Don't mess with me fellah, I'm a Loper.' Uncle John knew Eubie Blake. They played the piano in the sport houses in Atlantic City with their backs to the patrons. But they polished their pianos and could see who came in by looking in the upraised lid. They could see these special white well-to-do men who came to visit the prostitutes while their wives and kids went to the beach. So I thought of those men and did not let the men in the museum bother me. But you know I've always had a superiority complex. I did not respect them, so they

did not matter to me."

The *Morning News* reporters "loved it," Ed continued, "but they didn't write about it because the paper was owned by DuPont and this was not something the company wanted people talking about."

The color barrier in the then highly restricted Wilmington Society of the Fine Arts had been broken, and *After a Shower* propelled Ed into the Wilmington art scene limelight.

On the very day Ed told me this story, the *New York Times* featured baseball player Larry Doby on the first page. As I read the story, I realized echoes of Ed's story were repeated throughout the country during the 1940s and 1950s as color barriers fell.

Larry Doby entered the American League eleven weeks after Jackie Robinson had played his first game for the Brooklyn Dodgers in the National League. Lou Boudreau, the manager of the Cleveland Indians, took the twenty-two-year-old second baseman into the locker room in Comiskey Park and introduced him to his new teammates. "Some of the players shook my hand," Doby recalled for Ira Berkow, the *New York Times* reporter, "but most of them didn't."[14]

In Ed's case, and later Doby's, the discrimination only made them try harder. Ed, like Doby, never sought sympathy or felt sorry for himself. He simply persisted in entering pictures to the Annual Delaware Show, and he took his place alongside some of the best-known artists in the area. In 1937,

first prize went to *The Jones House*, a painting by Carolyn Wyeth, Andrew Wyeth's sister. Second prize went to *Dick,* a painting by Walter Pyle. In 1940, when Ed's *Behind the Tracks* was awarded an honorable mention, Andrew Wyeth's *Little Caddwell Island* received first prize. In 1943, when Ed's *Old Shacks* was awarded an honorable mention, N.C. Wyeth's *A Summer Night* received first prize. In 1947, two of Ed's pictures were accepted: *Bellevue Lighthouse* received first prize, and the Society purchased *Under the Highline.*

However, it was the 1937 award that brought attention to this former unknown black kid from Heald Street.

He received a $100 bill for the picture. According to two of his children, Jean and Eddie, in their neighborhood that translated into being "rich and famous." Eddie said the whole neighborhood turned out to look at the bill, to study it. No one had ever seen one before.

In school, before their father received the prize, the Loper children qualified for free milk. "They had just started giving us milk in these little glass jars," Eddie told me. "The milk cost two cents. But if you could not afford that, you got it free. After my father got the $100, we were told we had to pay for the milk. We never had the money, so we did not get any after that."

Five-foot-six-inch Eddie grinned, "I could have been taller if I kept drinking the milk."

Jean said her friends told her, "Your daddy's

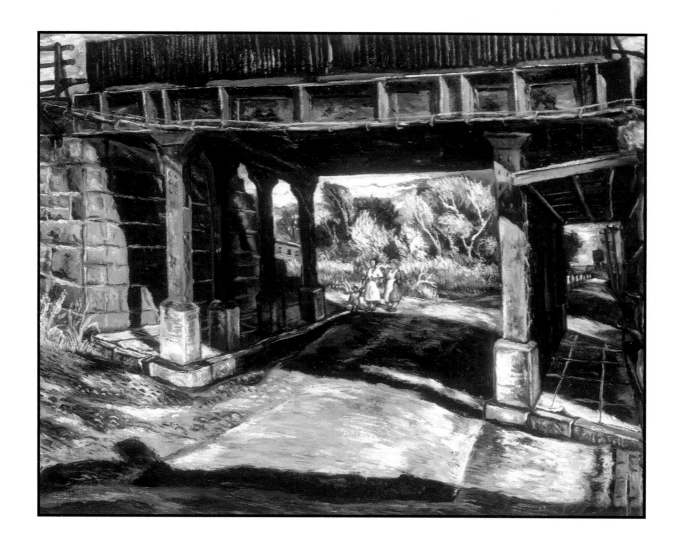

Under the Highline, ca. 1944. Oil on canvas; 21 ¼ x 29 ¾"; Delaware Art Museum;
Louisa du Pont Copeland Memorial Fund.

rich, and he can buy you anything you want. The prize also brought Ed a letter from Dr. Alain Leroy Locke—the first African-American Rhodes scholar, art historian, cultural philosopher, and author of *The New Negro*, the most important book on the Harlem Renaissance of the 1920s—requesting a meeting with him.

Ed thinks Dr. Locke had seen another of these early pictures, *Wind and Ashes*, a scene he painted of black people sifting through coal ashes at the city dump to recover small lumps of coal. This picture ended up in Alonso Aden's Whyte Gallery in Washington, D.C.[15] Aden was also the founder, with James V. Herring, professor of art at Howard University, of the Barnett-Aden Gallery in Washington, D.C., the first private gallery in Washington to break the color line.

Ed waited at the front of his Heald Street home and saw Dr. Locke, "a small man wearing little glasses pinched on his nose," come up his street. They went in the house to talk.

"I was a kid," Ed said. "I did the best I could to tell him about what I was doing. He was not the kind of black person I was used to. He was a scholar, an intellectual. I did not know how to relate to him."

Dr. Locke was impressed enough to include Ed's picture *Taking Down Clothes* in the 1940 edition of *The Negro in Art*. In 1942, he selected *Twelfth Street Garden* for a second place award at an exhibit at Clark University in Atlanta, the university where, in 1889, Henry Ossawa Tanner became the first African-American painter to teach at a black college.

Dr. Locke also invited Ed to attend a social gathering at Aaron Douglas's apartment on Edgecomb Avenue in Sugar Hill, New York City.

Aaron Douglas, known as the "Dean" among young black artists during the 1930s when he was elected first president of the Harlem Artists Guild, played an influential role in the Guild's successful battle with the WPA to obtain recognition for black artists. His own bold, distinctive work combined an angular style with faceted underpinnings and incorporated silhouettes of black people and objects.

Ed had never been to either Harlem or an apartment building before. He found everything about New York City amazing, especially the elegance of the black people he met that day.

"I was so young I thought the beautiful women there were old ladies, but now I realize they must have been thirty-five or forty years old. Everyone was nice to me, made a fuss over me," he said.

The party atmosphere did not lend itself to serious talk with Douglas about painting. Ed felt glad to be accepted into the group, and he felt comfortable there.

Later, when Ed was back in Wilmington, Delos O'Brian, a reporter for the *Sunday Star* and the minister of the First Unitarian Church in Wilmington, started coming around to talk to him. Impressed with Ed's skill and ambition, Reverend O'Brian dedicated a sermon to "His Art and His Race." In it, he said that one day Wilmington would be proud

that Edward Loper is a "native of this city." He based the talk on the parable of the hidden treasure, which he applied to Ed and his artistic talent. "Mr. Loper is significant," he said, "because he found opportunities in his own neighborhood and painted them." He also said the problem of racial prejudice is one of the "greatest problems of all time," and he urged his parishioners "to abandon the prejudices which set up barriers between men."[16]

When Ed told him how much he admired N.C. Wyeth's work, O'Brian asked him if he'd like to meet N.C.

The artists at the WPA had been talking about N.C. hanging out and drawing inside the Parkway Theatre (which opened in 1921, later becoming the Loew's and then the Ritz) at 900 Delaware Avenue in Wilmington.[17] N.C. sat in the back using a clipboard with a light attached to it. He used the scenes in the pirate movies to draw his subject matter. The men said he was smart to do that, to make an illustration from something real right before him.

Since Ed could not go the theater to watch N.C. work because black people were not admitted, O'Brian's offer felt like a gift.

Ed liked the big, strong-looking, beefy man with the mop of unruly dark curly hair he met that day. "He was a real man and he liked me," he told me. "This, in itself, was unusual. For a prominent white man to talk to a young, black kid was a big deal. White people treated us like we were animals. But N.C. and I would talk in his studio, a large barn clut-tered with the props for his illustrations. He was working on *The Island Funeral* at the time, and he had Pieter Bruegel's *Hunters* on the wall. It was a big reproduction, about 36 by 48 inches. I just stood around and watched him work."[18] After four visits, Ed believed he could now make his own decent pictures.

"I'm really thinking now," he said. "I'm going to museums and still studying the Dutch painters, and I'm still in love with moods and atmosphere. But Sam Fineman is still telling me I've got to get me a style. So after I met N.C., I went out in my yard and did a painting, and it looked just like N.C.'s work. I tore it up and threw it away."

Getting a style was not going to be easy, but Ed persevered.

He painted every day after work, using the graffiti-covered walls, train trestles, coal yards, houses with dilapidated porches, twisted fire escapes, and broken windows as subjects. The East Side and Eleventh Street Bridge neighborhoods, people hanging up wash, playing pool, and shooting craps all became his subjects, as did his wife, Viola. These pictures exhibit an awkward fusion of the artists he was studying on his trips to the Philadelphia Museum of Art: van Ruisdael, Corot, and Courbet mostly, but also Cecelia Beaux, a Philadelphia painter, and Thomas Eakins. "I was still being told, 'that's what great art is, getting this mood,'" he said.

Somber browns, punctuated by bright reds and oranges, a foreshadow of what his work would be-

come, mark these pictures. Like the beginning work of every artist, they show an unresolved use of sources: a Van Gogh swirl of trees lighting up the background space in *Under the Highline;* El Greco wisps of light snaking along twisted bodies and swirling clouds in *Black Crucifixion;* or Rouault-like heavy, black line punching out color shapes in *Sunday Afternoon.* Even in this early work, however, Ed began to reveal himself through the power and drama of his compositions. If people had been watching, they would have seen the strength of his personality imprinted in every picture.

Ed said he would have continued using values to model his volumes had he not seen a demonstration by Henry Henchy. His friends at the WPA told him Henryette Stadelman Whiteside had invited Henchy to the give a demonstration at the Delaware Art Center. Mrs. Whiteside had started the Wilmington Academy of Art in 1927. She had studied painting with Charles Hawthorne in Provincetown, the art capital of the East Coast, and she knew Henry Henchy had been Hawthorne's protégé. She had also helped raise the funds to build the Delaware Art Center which included classrooms and an office for the Academy downstairs.[19]

Ed went to see the demonstration.

"He started around the eyes," Ed explained, "and painted out to the edges. He had no lines, no markings at all to guide him. He just put in dashes of paint. I thought it looked like magic. I couldn't believe it was happening. There, all of a sudden, I could see a face coming together, just from the pieces of flesh-colored paint," he said. "It knocked me out."

Ed loosened his brushwork to try to obtain this painterly modeling. Later, Les Macklin, another WPA artist, enrolled in Henchy's classes in Provincetown and came back and said, "Henchy can't paint a darn. He starts out great, and then the whole picture falls apart."

Nevertheless, Ed felt he had discovered something important, a way to put color shapes next to each other until he covered the canvas. Then he could look at it and ask himself, "What did I do?" This helped break the hold of his rigid WPA drawing training.

By 1939, Ed's painting talents had been noticed at the WPA, and he moved to the Easel Project, headed by Walter Pyle, which allowed him to paint on his own and to choose his own subjects. When Walter Pyle needed a model for a mural he was working on in Claymont High School, Ed posed for him.

Ed was free to paint every day, anywhere he liked. He did not have to report until he finished a picture. He painted what he knew best, hoping to see things other people did not see.

Walter Pyle demanded at least one painting every couple of weeks for the WPA. Ed could paint any other pictures for himself. He would tell Walt what he was working on for the WPA, and then he would continue with the others. The WPA paid for his brushes, canvas, and paint for the work he did

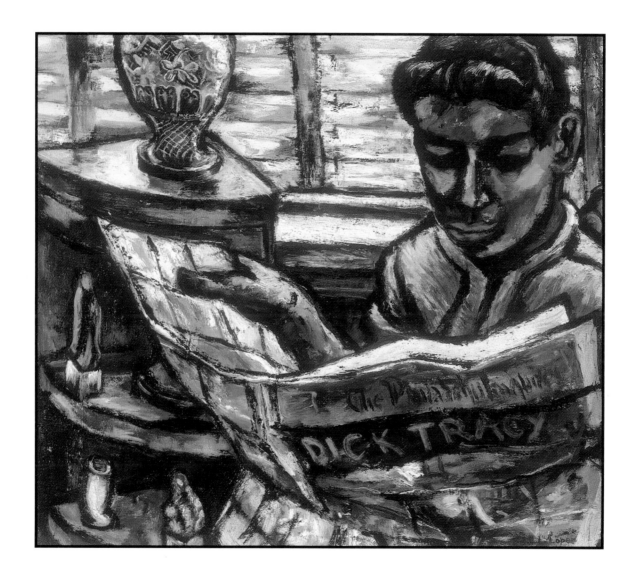

Sunday Afternoon, 1948. Oil on canvas, 20x24"; Courtesy of the Pennsylvania Academy of the Fine Arts, Philadelphia. Gift of Dr. George J. Roth.

for the Project; he paid for the materials he used for his own work.

"Did you cheat?" I asked him.

"When you are totally dependent on a job, you don't play tricks," he told me. "You only get smart alecky like that when you don't have to depend on a job for a living."

He worked every day, all day, beginning a habit he continued for twenty-five years. "I did it because I wanted to learn how to paint, and the only way to learn is by doing it," he told me.

He painted pictures using as subjects the East Side of Wilmington in the evening, looking down through the dark neighborhoods with the street lights just turning on or the marshes with their reeds and puddles of water. On rainy days, he worked underneath the railroad underpass at 12th and Railroad Streets.

"Slowly," he told me, "I realized people could recognize my work because I painted in a certain kind of way. I said to myself, 'Gee, I have a style. I don't even have to think about that. I just paint and they come out looking a certain way regardless.' Evidently, the style is something that is built in, so I gave up wanting a style."

He had gained the confidence to enter juried exhibitions across the country and had experienced success. In 1940, his teachers at Howard High School offered him a solo exhibition. The show was held in the second-floor Music Room which faced the front of the building. "I was excited," he said. "This was the first time I had any real recognition in my school. I had been the kid who didn't get the prizes. I also was the kid who many thought was good for nothing."

During the opening reception, Ed heard someone say, "Here comes Mr. Loper," and they looked out the window and "up the walk strides this elegant man with a bowler, striped pants, spats, shining shoes, cane, a cool man," Ed told me with obvious pride. "Turns out to be Levi Loper, my distant relative and the butler for H. Fletcher Brown. Later, when black people couldn't raise enough money to build the YMCA, H. Fletcher Brown funded the building of the YMCA at 10th and Walnut Streets because he liked Levi Loper," he said.

Ed felt proud that this black man, immaculately dressed and respected, was related to him.

Ed Sells Pictures

By the year I was born, 1941, Ed had received recognition nationally as well as locally. Prominent art galleries in Philadelphia asked to represent him, and Robert Carlen, a respected Philadelphia antique dealer, offered him a show. Carlen had opened a gallery on the ground floor of his center city home in 1937.[20]

Ed's thirty-five pictures sold the first day.

Carlen continued to sell Ed's work. He also suggested artists for Ed to meet or artists whose

work he should explore, and he invited Ed to attend the soirees given by Carlen's neighbors, the Leof-Blitzstein family to whom Carlen's wife was related by marriage.[21]

Ed remembers visiting the home of Mrs. Edmund C. Evans and Miss Ellen Winsor, other members of this group, and learning for the first time about the discrimination faced by Philadelphia's Jewish community. "I knew what black people had to endure," he told me. "These people made me feel much less alone."

Ed was impressed by Mrs. Evans' and Miss Winsor's home, a house that faced the Pennsylvania Turnpike. To him, it was a mansion. These white, Jewish art collectors befriended him, and he felt an acceptance he never experienced in Wilmington.

Since Carlen also represented Horace Pippin, a black artist living in West Chester, Pennsylvania, he introduced Ed to him and told Ed to visit Pippin and watch him work.

Ed went to the two-story frame house at 327 West Gay Street and knocked on the door. Pippin's wife answered and told him Horace was painting up the street. Ed found him working on *West Chester, Pennsylvania.*

"I watched him do the fence," Ed said. "I saw a solid wood fence, and I see him making slats with spaces between them. I see him putting in this blue color under the windows. I see these little flowers on the trees, and in front of me maybe there is one or two, but he's got a lot of them everywhere. I'm looking at the ground on the right corner and it is light. He made it dark. I didn't see the stuff he was putting in the picture."

Pippin stopped working and turned to Ed, asking him, "You know why I'm a great painter?" Ed shook his head no.

"I'm not like those white guys who make up stuff, who put all this funny stuff in," Pippin said. "I paint exactly what I see."

"It hit me, boom," Ed said. "He sees totally different than anyone else. He sees what he sees, not what's there that anyone can see. I made up my mind at that moment to paint exactly what I see. Because now I know if I do that it isn't what anyone can see unless I show it to them."

Ed decided that day that a real artist selects what is worthwhile and uses it to make a picture. If Pippin was painting things exactly as they are, then he was doing it the way they are somehow pulled through some quirky way he saw. "If that's what artists do," Ed said to himself, "then I want to do what he's doing."

"And Pippin was selling pictures all over the place, and people were calling him a great painter, too," Ed told me. "I wanted to get me some of that."

"If you do a subject in the way everyone can see it, then that isn't it, that isn't art, I'm now telling myself. Pippin had to make the ground dark so I could see the buildings. He had to paint blue under the windows to continue a pattern. And when I looked again, I could see the stain that settles into

bricks at the base of wooden window frames. But I never saw it until I looked at his picture, and I certainly never saw it as blue."

Ed took this idea with him that day: What he sees, others don't see. "If I see it, nobody else can unless I show it to them," he says. It now became his job to record his unique seeing so others could learn from it. And he had to do it his way, not Pippin's.

In 1940, Carlen urged Ed to go to the American Negro Exposition in Chicago so he could study the work other black painters were producing and compare it to his own.

Ed's friend Herman LaFate worked for the Pennsylvania Railroad and offered Ed one of his Worker's Passes.

Chicago was as big a shock as New York.

Ed rode the elevated train through Chicago and "saw more black people than I had ever seen," he said. He visited his cousin who lived in a "beautiful house with porches, but two families lived in it. So they divided it up with blankets."

"These trips out of Wilmington gave you more than a broader art education, didn't they?" I asked him.

"Yes, they showed me how black people could live, were living, in other areas. In a way, even though I felt impressed, I also came home angrier with my own reality," he said. "When I saw the beautifully dressed black people at the exhibit, I wondered why we were so far behind in Wilmington."

The work he saw depressed him as well. He found most of it repeats of the old masters he had seen in museums. He told me Hale Woodruff, the African-American painter influenced by Cézanne and the Cubist movement, was copying Italian paintings. Ed thought Woodruff's woodcut print *Returning Home*, depicting angular roof tops and patterned wooden slats on the ramshackle houses, looked like Byzantine design. "But I liked the Pippin's. I admired Pippin's work," he said.

Later, Carlen asked him to look at Rouault's work, and in a bookstore at 16th and Market in Philadelphia, Ed found a Rouault book and bought it. "I thought, what the devil, I don't think much of this stuff," he said. "I looked at the book every once in a while because Rouault got a lot of press. *Life* magazine devoted a couple of pages to Rouault burning up his pictures, the ones he had bought back. But I never got totally interested, except for the organization. If I held the book real close, the pictures looked woven together, the whole space was used. I liked that."

He continued working, using buildings, houses in Claymont, neighborhood scenes, and domestic scenes, such as his daughter, Jean, reading the newspaper or his wife, Viola, sewing. In *Nude,* the new ideas are clearly visible in the powerful figure pushed forward to fill the picture; the thick, encrusted paint quality; and the black line intensifying the brownish-red color harmonies. Less illustrative and more expressive, Ed was

Nude, ca. 1944. Oil on canvas; 10x8"; Delaware Art Museum. Gift of Michael and Pauline Luskin, 1955.

coming into his own.

One day, as Ed was making a painting using City Hall in Philadelphia as the subject, a photographer for a local newspaper asked if he could take his picture. While he snapped some photos, he asked Ed if he had a favorite artist. Ed told him Max Weber. Ed had seen Weber's work at the Pennsylvania Academy of the Fine Arts and loved the rich brushwork, the swift lines darting over the canvas, its intensity and eloquence.

The story must have been published, because a few weeks later Ed received a letter from Max Weber inviting Ed to visit him in Great Neck, Long Island. Judy Blam, a student of Ed's at the time, said she'd drive him.

They arrived at Weber's Spanish-style stucco villa and met the stocky, round-faced, silver-haired artist in his second-floor studio—a large enclosed porch with a fourteen-foot ceiling which faced the north light. Neat and orderly, the studio contained a storage platform for canvases along one side.

Ed admired Weber's persistence. He knew Weber had not had an easy time with art critics, perhaps best summed up by Manuel Komroff's 1915 article in the *New York Call:* "Weber was ridiculed, laughed at, starved, excommunicated, censured, refused, and annoyed as no man in art has ever been before. But he stood by the new spirit he had brought till it caught fire like a song in a revolution—and what happened then? Why, he was robbed, exploited, fleeced, pulled about, contorted by the imitators, and judged by the critics."[22]

Ed told Weber he was his favorite painter because his drawing was exquisite and he liked the abstractions in his work. They talked about *Rush Hour, New York,* but mostly Ed listened to Weber's take on the art scene.

"He told me he left the city because he couldn't stand listening to all the theories anymore, all the controversies about what art is or isn't. He found it ironic now that he was an older man, that people liked his work. When he had lived on Third Avenue in Greenwich Village and washed clothes in a sink, he would have liked to have had money. He told me most people don't know what they're talking about. He explained that he'd been told never to put an object in the center of the picture; that was a big rule at that time. He showed me in one of his paintings how he broke the rule."

Ed was amazed. Up to that time, he believed people who talked about art knew their subject. He always felt dumb because he did not have an art school or educated background, yet here was a man he respected telling him everyone went dumb on the subject of art.

Weber told him that many painters jump on the latest trend and then never have anything that belongs to them. He warned Ed never to do that, to always try to paint, as Matisse said, so people know you did it.

Weber also shared how he corrected pictures. Weber took colored chalk and went over his picture

to see how it would look with the new colors. If he was wrong, he simply had to wash the chalk off with water. If it looked good, he went to work with paint. Ed used this technique from that day on.

Weber asked him if he had any other favorite artists. When Ed replied, "Abraham Ratner," Weber launched into an explanation of "baked" color, color that resembled bread left in the oven too long. Ed marveled at this negative analysis of Ratner's color and found the description useful when he needed to soften the grainy, impenetrable quality of his own color.

Ed Stumbles Onto Color

By the mid-1950s and early 1960s, Ed's work incorporated the abstract underpinnings he enjoyed in Weber's *Rush Hour, New York* and in the Cubist paintings by Picasso. He now used bold, dark lines juxtaposed with fragments of color. Weber's still-life pictures, such as the 1920 *Still Life,* showing a sugar bowl and fruit on a table top as subject, or the 1950 *Still Life with Apples*, intrigued Ed because of the heavy black outline and the thick, obvious, vivid color shapes.

To find fresh subjects, Ed began to travel. He first went to Provincetown, Massachusetts, and enjoyed the narrow, crowded streets and lively boat yards. "The Portuguese treated us so nice," he told me. "I thought it was wonderful."

Then he took his family to Gloucester, Massachusetts, and found it even more interesting than Provincetown. Flat sandy beaches contrasted with rugged, rocky coastline. He found coves tucked away near Rockport, and he discovered weathered fisheries, rusted anchors, and propellers—a smorgasbord of objects to use for making pictures.

He figured since Provincetown and Gloucester were north and he did not encounter any racism, he could go on to Maine as well. They next went to Ogonquit, Maine, and stopped at motels with vacancy signs. But as they went from motel to motel, the motels suddenly became "filled."

He could not find a place to stay. As he drove around with his family, he spotted a woman walking, and he stopped his van and asked her where they might stay. She told him there was a house where "your kind of people" stay. "It catered to the butlers and chauffeurs of the white folks," Ed said she told him. His family rented a room there that night and drove home the next day.

Later, he found out Maine motels did this all the time. He talked to a friend who was quite "light" and looked white, and Ed asked him where he could go where he would not run into "this racism." The friend told him to go to Quebec. "The French-speaking Canadians are without racism," his friend told him. He warned him to stay away from Toronto, however, "because the English-speaking Canadians are racist."

The next year the family traveled to Canada. At

the border, Ed told me, they were treated with such respect and civility, he felt amazed. "The border guard actually said 'I hope you have a nice time.'"

As they drove toward Montreal on the single-lane road, Ed said he felt free for the first time in his life.

The next day they arrived in Quebec City, and Ed fell in love with it.

He found a spot to paint on Cote de Montagne, looking down a hill. As he worked, the owner of Zanatin Gallery came up to him and, after talking awhile, told Ed he wanted to introduce him to a young artist, Benoit Coté, one of Quebec's better-known painters. Benoit soon arrived, and a friendship developed which continues today.

Benoit introduced Ed to other painting sites and invited him to return the following year. This pattern continued into Ed's eighties.

Quebec City helped Ed fine tune his color perception.

"I started to look at cement walls and noticed the deterioration on the walls was different colors. In Quebec, the stone walls and plaster walls were not the same colors. I tried to get the actual look those walls had, the crumbly color of plaster, the rust, and I just stumbled onto color," he said.

"I couldn't get it with shading. I had to use greens, grays, tans. All had to be a different color. At home I started looking at colors under bridges and underpasses. I no longer just painted black, but the different colors the black was made of." Oranges and reds began to dominate his compositions.

In the 1960s, he started bringing classes to Quebec City for two-week sessions. He continued doing that for thirty-five years.

At this point, he now attracted many more students who had been to art school or college, and he wanted to know how to explain ideas to them. He feared disappointing them with his limited understanding of what art was about, and he felt increasingly frustrated by the conflicting and often confusing answers he got to his questions. And he still could not evaluate the quality of the art he saw in shows.

For example, when a student, Boots Keyser, invited Ed to accompany her to the Pittsburgh International Exhibition of Contemporary Painting held at the Carnegie Institute, a museum of fine arts known for its international exhibits of contemporary painting, Ed found he could not tell the good art from the ordinary. He did not like the few Picasso's and Matisse's he saw. Abstract Expressionism, work by Pollock, Kline, and Rothko, bewildered him.

He fell in love with Jack Levine's pictures, Social Realist painting calling attention to the particular despairs and evils of the time or "gangster pictures," as Ed called them. Impressed with how Levine exaggerated features as a cartoonist does and distorted physical scale to achieve emphasis, he wondered why the press seemed excited by Picasso's pictures. In comparison to the Levine's, he thought they were junk.

"This was the best thing for me," he told me. "I figured something is wrong here. I'm wrong, on the wrong track. I could not understand why critics thought the Picasso's were important."

If he felt frustrated by his inability to evaluate the quality of the work he saw, he became outraged when he could not understand the language people used to describe it.

A friend of his, Hilary Bloom, who lived in Arden, Delaware, a village founded in 1900 on Henry George's concept of single-taxation and a community of artistically oriented people located six miles north of Wilmington, talked to him one day about "plastic art."

"It's so plastic," she told him. "I asked her what that meant, could she show me what that meant. I kept asking and asking. I felt stupid."

She finally told him, "Ed, if you can't see it with your own eyes, you must be blind." The comment "burned me up," he said.

He hated the subjective nature of most art talk. He hated the pulling of class and education that made him feel inadequate. And he did not know what to do about it.

Ed Learns How to Put Art Into Words

One day during his class at the Delaware Art Museum, Ed went into director Marian Johnson's office and stood looking at the books. One small red book caught his eye, *Art and Education,* a collection of essays by John Dewey and Dr. Albert C. Barnes among others. Ed picked it up, thumbed through it, and saw a chapter on plastic form written by Dr. Barnes.[23]

"The world stopped for me then," he said. "I started reading this incredibly simple, plain, easy-to-understand information about plastic form, and I just read and read. I forgot all about the class. It was just as if it were being shown to me. I understood it. I was always told Dr. Barnes did not know what he was talking about, and here I was soaking up his words in that chapter."

Dr. Barnes, the medical doctor turned art collector, who had built the Barnes Foundation to house his art collection as well as teach others to appreciate it, defined "plastic." According to Dr. Barnes, "anything that can be bent or worked or changed into a form other than that which it originally had [is plastic], and for the painter the merely factual appearances of things are plastic: they can be emphasized, distorted and rearranged as his personal vision and design require."[24]

Light can be plastic in its effect on color: It can permeate color and cause it to glow; it can shine on color and cause it to shimmer. Line can be plastic in its effect on space: it can punctuate a flat surface according to rules of perspective creating the illusion of deep space. From Matisse's hand, it can curve

and turn, creating a voluptuous mass.

To Barnes, "plastic" retains the same meaning as the use of the term in plastic surgery: malleable, changeable.

Dr. Barnes defined design in plastic art as "analogous to the thesis of an argument, the plot of a novel, the general structure of a symphony, the 'point' of an anecdote: that is, the feature or detail which assigns to each of the other elements its role, its bearing, its significance."[25]

Ed had discovered one of the most important essays Dr. Barnes wrote.

In it, Barnes described how an artist uses color, light, line, space, subject, and tradition to create a plastic expression of an individual human experience.

It works like this.

A picture has a main idea. In one of Ed's pictures, for example, *My Father, the Bishop*, the main idea is power. Look at that picture, and you cannot help but be excited by the strong contrasts of light and dark, the intense color, the poised strength of that outstretched arm. Ed's use of light, line, color, and space contribute in some way to the expression of that theme.

Dark and light units crash against each other, color is punched out because heavy black line encloses each color unit, and a shallow space is punctuated by thrusts of arms and organ pipes in a compressed area: All this works together like a smooth-functioning team, saying "power."

It made sense, Ed thought.

He had heard of Dr. Barnes and had even met him and visited the gallery in Merion, Pennsylvania, years before.

One day, in the mid-1940s, Ed was visiting Carlen's gallery when the doorbell rang. Carlen told him it was Dr. Barnes coming to look at some early-American antiques he had.[26]

"So this man comes in," Ed told me, "a fairly nice-looking older guy with gray hair. Bob introduced me to him, and Dr. Barnes told me he knew my work and would like me to come to the Foundation. My wife had just died, Merion sounded like someplace I never could find, and I did not have a car, so I politely refused."

Then Bob asked Ed to wait in the other studio until he completed his business with Dr. Barnes.

Ed heard loud shouting and "yes, yes, yes" and "no, no, no; hell, no" going on. He stood there laughing, thinking that Carlen wanted things his way and so did Dr. Barnes.

When Bob returned to Ed, he complained about Dr. Barnes being cheap. "All that money he has, and he has to fight me down on a bunch of antique plates," he told Ed.

Bob had just sold Dr. Barnes a set of blue spatterware plates. Ed saw them when he finally visited the Foundation a few years later.

One of his students, Beatrice Mark, wanted to see the collection. She wrote a letter and asked if she and Ed could visit.

My Father the Bishop, ca. 1975. Oil on canvas; 48x36"; Collection of Janet and Edward L. Loper, Sr.

After she received permission, she drove Ed to Latches Lane near Merion and parked at the black iron gate. They walked to the main entrance of the gallery. There at the top of the steps, framed by the colored ceramic tiles modeled after a door relief of a mask and a crocodile made by the Akan peoples of Ivory Coast and Ghana, stood a small, wispy-haired woman smiling at them.

Miss Violette de Mazia, Dr. Barnes' associate, teacher, and co-author of *The Art in Painting, The Art of Renoir, The Art of Henri Matisse, The Art of Cézanne, The French Primitives and Their Forms,* and writer and editor of the Barnes Journals, simply said, "Welcome, Mr. Loper. Welcome, Mrs. Mark. How are you?" and opened the door.

She left them alone to look at the collection. Most of the pictures were novel to Ed because he had never seen some of these painters' work. "I drooled over the El Greco's, but I had already discovered his work in the Philadelphia Museum of Art and the Phillips Gallery in Washington, D.C. The Cézanne's and Renoir's I had no idea about, no one had seen them yet. The Picasso's and Matisse's still confused me," he said.

Now, much later, in 1963, in that room in the Delaware Art Museum with *Art and Education* in his hand and Dr. Barnes's clear explanations filling his head, Ed decided it was time to take Dr. Barnes up on his offer. He had a car, was teaching at his studio in his home and at the Art Center, and wanted answers to his questions.

Told he had to write a letter and be interviewed, he said in his letter he had no real understanding about art.

When Violette de Mazia interviewed him, she asked why he wanted to study at the Foundation. He told her about Dr. Barnes's visit to Carlen's gallery, the argument over the spatterware plates, and his car. "Now I can get here, and I know how to do it," he said.

During the first year, Ed attended Miss de Mazia's lectures. Miss de Mazia likened that first year to the drilling of a tooth, preparing the foundation for the solid filling that would come next.

It could be just as painful.

Students sat on hard wooden folding chairs, though some purchased cushions to provide a little comfort. Her lectures began at 1:00 p.m. sharp and generally ended at 4:30 p.m. One short break allowed students to turn their chairs to the opposite wall to view the setup of pictures at that end of the room.

The pictures she would discuss that day were set up on easels or tables. Miss de Mazia explained the purpose of the day's talk, and then she started lecturing about what was going on in those pictures, why they were structured the way they were, who influenced that painter's style and how. She demonstrated each point by showing the effect in the picture.

While many of her students stubbornly clung to preconceptions regarding subject and history, preferring stories about the artist's life to the hard work

of visual scrutiny, she slowly and meticulously tried to dig out these stumbling blocks to aesthetic appreciation.

Ed learned to follow her expressive hands as they pointed to units in each picture. He learned to see, not just accept, the visual idea her words described.

He also did his own looking.

"I studied the small Cézanne of the little boy in the main gallery," he told me. "Every quarter of an inch was a different color. Colors everywhere. Not intermingled. I wanted to learn how to do it as well as Cézanne. I figured if he could do it, he had to learn how to do it. I saw the differences in his early and late work. Miss de Mazia lectured on the differences. And I learned all artists' work changes, sometimes grows richer, sometimes not. I found it all encouraging, learning about how other artists learned to do things. If they changed and got to be able to do things, all of us had a shot at it. If I worked at it, I could get better. Just like basketball and football had been for me."

For Ed, Miss de Mazia's lectures opened up a new world.

"She put this picture up on an easel in the front of the room," he said. "Then she pointed to this and that in the picture, showing how the artist moved the eye up the left side and across the top. Or she connected lines, one with another, to show the theme and variation. Or she showed how one color shape connected with all the others. I never knew about the art in pictures before. I was busy with skill."

He felt suited to the Barnes method. The link of painter to painter, of idea to idea, throughout the history of painting, echoed what he knew about jazz. "No one is a genius all by himself," he told me. This idea spoke to his deepest convictions about his own development. "Painting evolves, just like jazz evolves," he said.

He liked that idea.

After Miss de Mazia's lectures, Ed went on to the second-year class. In relatively shorter lectures, a mere one and a half hours or two, Harry Safarbi unwrapped the history and traditions of art, century by century, filling that excavated tooth with the images of visual art.

The second year built background.

Then he entered the seminar. Now the students practiced what they had learned. They could select any subject that interested them and, applying the Barnes method, reveal the art in it.

"Jazz music was the easiest one for me to talk about in the seminar," he told me.

He remembered hearing Della Reese on television telling a story about her singing. After she performed, someone came up to her and said, "You're a great singer. You sound just like Billie Holiday." Della Reese said she went home and cried.

That's what should happen in painting, Ed learned. "If you ever do it exactly the same way some other artist did it, then you're no good."

Ed felt he had something that belonged to him

from the start. It might be dark and heavy, but it was his.

He had added Henry Henchy's loose, broken color pieces. At the Foundation, he had looked at Cézanne and started to build strong, geometric compositions. He thought if he could bring all his background together and fuse it with his Loper-ness, he might just do something important with color, something that had never been done before.

Ed believed Cézanne layered patterns over patterns, just the way the jazz musicians did. The musicians took a song and broke it up into pieces, layering notes over the top, and weaving the whole thing into one ensemble.

He wanted to do that in pictures.

He decided he had been painting what other people thought were good pictures. He had been using the formulas of people whose work he admired.

Now that he understood what art was about, he could start using his own formulas.

"What I learned at the Barnes Foundation changed my life completely," Ed told me. "It gave me insight into what I was doing. I had no idea what I was doing before I went there. Ninety percent of painters don't have any idea what they are doing in their own work. But after Barnes, I could cover a canvas and then ask myself, 'What have I done?' Then I analyze the picture and see the answer. Then I can ask, 'Now what do I want to do with this? How can I enlarge on what I've done to make it more ex-

pressive? Or how can I subdue those things that destroy the expressiveness of what I've done?'"

Those Barnes years also gave him a vocabulary, a clear way to talk about art, making it easier for him to badger and bully his students to see the world his way.

I Learn How to See

Two years later, I walked into his class at the Art Center and our worlds connected.

In case you forgot, my doctor told me to take up a hobby to aid my quest to get pregnant. I intended to relax and enjoy making pictures.

Little did I know the paths he had traveled. Little did I know what paths he would open to me.

I did know that very first day, however, this was no way to relax.

By the time I entered Ed's class, he was both confident and angry: angry because his work had not received the recognition he thought it deserved in Wilmington, much less Delaware, and more confident than ever he was on to something important.

The teacher I met that day at the Delaware Art Museum taught like a drill sergeant who snapped commands. "Color next to color," he barked. "No skipping. How light is that color? What shape is it? Compared to what's next to it? Compared to the whole ensemble? Look at it. Don't guess."

From the moment I selected one of Ed's com-

plex still-life arrangements, I had to defend why I made every line, every shape, every choice. He showed me other artists' work to give me ideas. "Look at how Picasso distorts the table to move the eye up the picture," he said. "Look at how Rembrandt darkens the edges to focus the eye on the center of interest."

During the first six months, I felt stymied. Ed pointed. I looked. I did not see more than the basic labeling color: lemons were yellow, apples were red. After one particularly cantankerous session, a fellow student advised me, "If the lemon looks yellow, paint it any color but yellow. Then he'll leave you alone."

I'd come home crying.

"Why don't you quit," my husband would ask me.

I did not quit because I was intrigued by the work of the advanced students in the class who were painting vibrant, kaleidoscopic pictures using rich, exotic color harmonies. I had never seen anything like those pictures, and I wanted to do what they were doing.

It took me six months before I saw color, and it happened on a drive home after I decided to quit. I had another bad day in a park near the Brandywine River trying to see more than light green, dark green, and medium green in trees and grass. I finally had enough, and I threw my paint box into the trunk of my car and drove off, telling myself I would not be back. Not only did I not see color, I also had not conceived. I felt quite sorry for myself.

But then, as I drove, the trees along the road came alive for me in color, just as if I had turned a lens on a camera and all of a sudden everything focused clear, bright, and purple, red, orange, and blue. I pulled over to the side of the road and just stared.

I had a vision. The Ed Loper Vision.

Chasing Colors

Now converted, this meant I returned to Ed's class with a new attitude. I felt driven to learn more quickly, to catch up to the others, to see more.

Once I could see colors or, more precisely, once they revealed themselves to me, I had an obligation to make the color shapes as fast as I could and put them on my canvas, like fitting jigsaw puzzle pieces together. To get the idea of this, picture my first poodle, Macduff (a big name for a small, curly creature, but as noble and steadfast as his namesake), chasing rabbits on my in-laws' Colorado farm. He began by chasing one rabbit and, just as he got close enough to taste it, it popped down a hole and another popped up close by. So Macduff, never realizing he had been tricked, never lost a step and went after the next one and the next one and the next one. He would have kept running until his little heart exploded if I had not whistled him back for a biscuit.

So it is with colors. I'd put down the first one

I'd see and then another popped up right next to it, and I'd make it as fast as I could, and then another popped up, and another. I'd get so involved with colors hours would go by, my joints would stiffen, and I'd forget to eat. I covered whole pictures this way.

In the beginning, my pictures looked like a cross between Modigliani and Picasso, two artists whose work I had probably laughed at in my teenage trips to the Museum of Modern Art. When Ed hired an old man wearing a blue hat to pose for us, I drew an elongated neck and oval head and filled the canvas with his upper body. I used geometric, densely pigmented color shapes. I still have this first picture, made after I could see color, and when I talk to students about adapting tradition, I contrast it with that clown I made when I was sixteen years old. My new painting students generally prefer the clown, proving only that aesthetic appreciation is an acquired taste.

But my real work had just started.

My color was "burnt," Ed told me. I should look at Juan Gris' work so I could learn how to use grays, how to soften my color. And I tried. But I could not find any books, any articles, any encyclopedia or dictionary entry for this obscure artist. When I told Ed that, he stared at me for a long moment, and then asked me how I was spelling his name. "W-a-n-g-r-i-s-e," I replied.

"You've got to go to the Barnes Foundation," Ed told me without so much as a smile, "so Miss de Mazia can sharpen you up."

So I did.

Unlike Ed before me, once I got there, I stayed twelve years.

Ed's teaching had prepared me to respect Violette de Mazia, but I fell in love with her sometime during her first lecture. I had never listened to anyone talk about art the way she did, not even Ed. Her lectures were, in themselves, little works of art, and her descriptions were so clear and precise, I could validate her every point by looking at the painting before me.

After the second-year class, a thorough chronological presentation of the traditions of art led by Angelo Pinto, a gentle, soft-spoken man who at first disappointed me only because he wasn't Miss de Mazia, I entered the seminar. There I stayed for ten years.

The first two years of classes gave me a background and a vocabulary. I learned, among many other things, how to spell Juan Gris, how to understand his contribution, and how to read his work. And I could put into words what had happened to me since the day I walked into Ed's class.

In the seminar, I prepared lectures adapting the Barnes method to my life experience. I analyzed Ed's work, my own work, the work of other Ed Loper students, and the work of my own students, including my daughter. My daughter Alisa began painting when she was two years old, made watercolors to die for by the time she was ten, and, at twenty-

one, received a B.A. degree in, no, not fine art, journalism. She is now a writer.

Yes, I did have children. I adopted my first son, Andy, soon after I started to see color. Then I conceived a daughter, Alisa, and a son, Mark.

Ed told me Andy came "with a pollen on him." He continues to tell this story every chance he gets to anyone who will listen.

Around this time, neighbors begged me to teach their kids to paint, so I invited five eight-year-old children, mostly playmates of my oldest son, to try it out. First they worked on my kitchen table; then they worked in my cold, unfinished basement. As their numbers increased, I went down in my basement, a cavernous space with an above-ground sliding glass door and, up to now, used by my kids and all their friends as an indoor big wheel and bicycle track, and I decided to put up walls. I listened patiently to all the reasons why my children had to have that big, open play space, but I built a studio anyway. Twenty years later, I still teach in it.

With Ed's encouragement, other students did the same thing: Ruth Anne Crawford, Eddie Loper, Jr., Mary Kay Fager in Harrisburg, and Al Staszesky, to name a few. We produced more painters who use direct perception of color shapes coupled with geometric structure to produce dramatically powerful and boldly vivid pictures. They are obligated to see that the vision survives.

The going will not be any easier for them than it was for Ed or us.

A New Tradition

Even though Ed received recognition as an accomplished artist, certainly one of the most influential in Delaware, despite the obstacles, the poverty and the racism, he never felt his work was accepted and valued.

As the art world sped on, one trend or another became the "greatest thing ever done" (pop-art, op art, photo-realism, super-realism, earth art, concept art). Ed Loper's vision, to many critics, seemed mired in the past. He should move on, the critics said. "Ed Loper has painted himself into a corner,"[27] the *News Journal's* art critic, Otto Deckom, said in 1964.

His work neither satisfied those critics who wanted a black artist to paint black themes nor those who wanted him to jump on the latest trend. In fact, and most depressing to him, since most of his students were white, he was perceived by some black people as an Uncle Tom. Many felt betrayed when he ignored the civil rights movement in the 1960s.

Ed overheard students being asked, "Why do you go to classes taught by that black man?" In Rockport, Massachusetts, during an outdoor painting class, the occupant of a house near Motif #1, so-called because it is the most painted house in the area, burst out his front door shouting, "I don't want that black man with all his white women on my property."

Ed did not know where he belonged.

Wilmington News Journal reporter Bill Frank said he thought of Ed Loper as an "immigrant in his native land."[28]

Then, when his students started entering juried shows, critics said their work looked too much like his. Students were warned by their friends not to study with him. "He will ruin you," they were told.

The saying became: All Loper students paint alike.

Ed felt so discouraged by this stream of criticism he telephoned Violette de Mazia and made an appointment to talk with her. He explained to her how distressed he felt. If he was doing harm to his students, he was willing to stop teaching.

She asked him to collect ten paintings from students who were showing their work and entering juried shows and to bring one of his own as well.

"I felt nervous as hell going to see her," he told me. "I thought of her as a genius, the smartest person I ever would know in my lifetime. I even was afraid of her, and I never had the sense she liked me. But I was desperate for an objective opinion. And I knew she would give me that."

Ed drove to Miss de Mazia's home, a Tudor-style brick house in an elegant neighborhood of upscale homes not too far from the Barnes Foundation. Unsure at first if he arrived at the right house, he drove by it and circled the block. "I did not want to get out of my car and wander around in that neighborhood if I was in the wrong place," he said.

When he finally knocked on her door, she immediately opened it and said, "You're late."

He explained his confusion, and she admitted she had seen him drive by the first time. He felt she understood his concern.

Ed looked around and saw paintings everywhere, not just on the walls. They were stacked behind the couch and propped up in corners. He saw pictures by Matisse, Renoir, and Glackens, casually stored as they would be in an artist's home.

Miss de Mazia asked him to place the paintings he brought with him around the living room. Then she sat very still and examined them. After about fifteen minutes, she said: "No, they don't paint like you, and they don't paint like each other. It looks like you people in Wilmington have started a new tradition."

No small thing, this.

This means Edward L. Loper, Sr., out of grit, determination, curiosity, and persistence, invented a new way of seeing.

A new way of seeing is not a style. A style implies a cosmetic transformation, like a face lift, for example, that removes wrinkles but leaves the old psyche intact.

A new way of seeing uncovers deeper realities, those invisible qualities that situations, things, and people can have for us if artists make them visible, thereby showing us how to see them.

Ed took the twentieth century's fascination with non-objective abstraction and combined it with the

Still Life, 1990, by Marilyn Bauman. Oil on canvas; 40x36"; Collection of Marilyn Bauman.

Still Life with Basket and Fruit, ca. 1991, by Edward L. Loper, Sr. Oil on canvas; 36x46";
Collection of Ellen and Jim Semple.

visual qualities he loved in very ordinary things, places, and people: massiveness, boldness, drama, and power. He uncovered those qualities in the everyday things around him, as though he had magic powers, as though he waved his brush at a group of tenements and said, "Reveal meaning to me." And then he put one color next to another until he had its essence captured on his canvas.

I tell my students we must look for colors or they hide from us. "Show yourselves to me," we have to say to them. And then they do.

Or, as Ed puts it, "If you're looking for trouble, you'll find trouble. If you're looking for color, you'll find color."

But seeing colors is only a part of the process.

Ed had the ability to select from the work of other artists those ideas he needed for his own research. He did not steal them. He adapted them to suit his vision and his discoveries.

Miss de Mazia told us this is like borrowing money from a bank and paying it back with interest.

I tell my students it is like taking Thanksgiving roast turkey and, instead of serving it warmed over the next day, making turkey frame soup. In the pot goes the leftover turkey, water, tomatoes, carrots, celery, onions, and those spices my mother added to her soup, modified a little bit to suit my taste. And then I have my turkey frame soup. Sometimes, when I do it well, it is a work of art.

Finally, inventing a new tradition means obli-gation. You're stuck with it. Ed could no more vary his painting to suit the popular trends of the day than he could change the color of his skin. Even when his work depressed him, when he grumbled because it was so dark, so heavy, so "out of vogue," he was stuck with it.

He could keep hunting colors. He could keep asking questions. He could keep looking at other artists' work. But he had to paint the way he painted and no other way, no matter whether the paintings sold or were accepted into shows, no matter if anyone liked them.

At first, viewers respond to the vision's similarities: busy, vivid, dramatic pictures, with objects filling the canvas space, and a tendency toward heavy pigmentation and abstract underpinnings.

Later, on close inspection, they see differences as apparent as the differences among Pissaro, Monet, and Renoir.

Students find ways to individualize the vision. They make their own journey their way, responding to and adapting the work of the artists who move them in an aesthetic way.

Students who also become artists usually go it alone after a time. They must find the subjects that interest them, not those prearranged by Ed. And they must bring their pictures to completion without his suggestions. They must make their own mistakes and solve their own problems. Nothing else works.

Each of them will admit going it alone takes courage.

When I explained to Ed that I had to try my wings, he did not try to talk me out of it. He said, "It's time."

Those first months remain the most exhilarating I have lived. Although I suffered bouts of self-doubt (fears I could not paint, find the colors, finish a picture), I also soon realized Ed's words were in my head. I heard him saying, "What color is that? How light is it? Compared to what's next to it? Compared to the whole ensemble?" I had him looking over my shoulder, asking, "Why did you choose that subject?"

Some days I dreaded going to work. "What if I get there and don't know what to do," I'd ask myself. But I got there and went to work. I painted picture after picture during a glorious summer of non-stop work.

I found subjects, models, even set up still-life subjects for rainy days. I found places to travel that suited me: Key West, St. Augustine, Cortez in the winter; Colorado, Gloucester, Nova Scotia in the summer.

And when I showed my work and Ed saw it, he said good things about it.

Artistically, I grew up.

Did I miss him? Yes. Did I miss the group? Of course. It felt like I had left my family, my nest. When we had parties, I felt outside the conversation, distant from the others, like a stranger looking in. "Why don't you come back to class?" students would ask me. "Because I can't," I'd tell them.

In those six years, I learned what interested me, and I learned to understand my own work. I now knew what Bauman liked, what she tended to do in a picture, the kind of subjects she needed, the rhythms of her creative impulses.

It takes courage to be an artist. It also takes a stubborn "aloneness," the willingness to, as eloquently stated in the *Rubáiyat of Omar Khayyám*, "Remold the world, bringing it closer to the heart's desire," without help, without advice, without assistance of any kind. And it takes obligation to the work, the firm conviction that a picture must be painted if a subject reveals itself, no matter if no one else likes it, buys it, or even sees it.

Then, when the picture is finished, the frame applied, the nail hammered in the wall, the artist can look at it as if for the first time and try to understand it.

In *The Everyday Work of Art,* Eric Booth offers a clear description of this process. He calls yearning "our heart's desire; the spirit's urge to discover itself in forms."[29] "Entelecy" means the full realization of one's inherent potential. "Realizing our entelecy, yearning our way toward it, takes work: the work of art," Booth argues. Think of it like Tiger Woods's natural ability linked to his father's daily golf lessons.

In Ed's case, the WPA provided the lessons that allowed Ed's almost dormant sense of wonder, submerged under the demands survival imposed, to blossom. With less yearning, he would have been

content to learn the skills of art and stop there. But Ed's entelecy demanded more, and he made a commitment back, a promise to "teach whatever he learned" and a promise to discover what art was all about. Booth calls this skill to make a committed promise back "response-ability,"[30] the ability to respond. Ed never made excuses: from his first teaching job to his first entry in a juried show, he took full courageous responsibility for his preparation, his skill, his choices. He boldly put forth his work and never apologized for it.

In my case, after I accidentally walked into Ed's class at the Art Center, I could have been content to remain his student. But my entelecy demanded I find out what I could do without him. My apprenticeship needed to end before I could explore my own vision. All apprenticeships need to end. As Eric Booth says, "The master is willing to guide the apprentice toward his fullest competence and then let him go."[31]

When I felt discouraged by rejections to juried shows, lack of sales, lack of reviews, or, as Virginia Woolf calls it "poverty and obscurity," Ed never permitted whining. "It's what we do," he told me. "It's our happiness."

And it is. From my first interested look at a new subject—that moment when I pass a familiar scene I have looked at for years and suddenly something shifts, like the moment when a camera lens slips into focus, and I exclaim, "That's a picture!"—to those precious colors I perceive and struggle to make that

surprise me with their newness and subtlety, to the working out of the picture itself, color next to color until I can clearly see what it is I felt excited about when I started, all this makes the work worthwhile. All this continues to challenge me. All this informs my life.

None of this is easy to explain to those who do not share the passion. "Did you know what you were getting into when you started writing this book?" a friend asked me. She meant, did I fully realize I would be researching, writing, rewriting, and editing for years? Without compensation. Without any guarantee the book would be published.

No, I did not. And, no, it doesn't matter. The work itself—the daily habit of talking with Ed, piecing together what he told me into a unified story, supporting his reminiscences with library research, finding just the article I needed after weeks of searching, meeting with helpful people along the way, the writing itself, the polishing of that writing, finding just the right phrase, image, fact—was its own reward.

As I look back, I remember moments of pure joy: as I jogged in Fort Lauderdale, the instant I connected Ed's teaching to Old Testament prophet Jeremiah's; as I walked my dog, the exact spot down the hill from my house at the base of Elderon Drive near the Arundel Swim Club that I realized Ed's experiences paralleled my own, and I knew how to organize the largest sections of the book; as I was about to give up locating Saul Cohen's obituary since

Ed did not remember the date or place of his death, I located the Jewish Historical Society of Delaware and archivist Julian H. Preisler who had it in his files.

This is the *work* of art. In Eric Booth's eloquent words: "What is important is the doing of the work, not the quality of the resulting products, not how you feel about the work or how the work makes you feel, not what others think of what you are doing, or what you are going to tell them about your doings. The engagement in the process is the whole enchilada; everything else is a fringe benefit."[32]

This is what Ed teaches. His class does not merely fill spare time. His students discover he informs a way of life: hard work, commitment, involvement, and passion.

His students gain more than a fulfilling hobby. They have their lives enriched by their encounters with the Prophet of Color: an angry black man determined to fulfill his destiny despite a society equally determined to keep him in his place.

Lamentations

All Black Men Are Angry

Using a tin can stuffed with rags and a hoop made from a hollowed peach basket nailed to the side of a barn, eight-year-old Edward Loper shot baskets over and over again, two-handed at first, then one-handed.

In this alley on 12th and Thatcher Streets directly in back of his home on Heald Street, Ed taught himself to make baskets.

He had watched the cheerleaders at a local game, and he noticed how girls liked boys who could shoot baskets. He also knew black boys had a chance with sports. If he got good enough, he would make the team. If he got good enough, he could win at something.

When he went to junior high school at Howard School, he shot well enough to make the junior varsity team and show off for the girls. They were es-pecially impressed with his one-hand shot.

He also ran track, becoming #5 on the relay team, and played playground volleyball. His volleyball team, he told me, was the best in the city, and other neighborhood teams frequently came by to challenge them.

He played baseball, too, but never belonged to a team and was not a "star."

Football, however, was a different story. At Howard High School, Ed became a right halfback. He was 5'10½," 155 lbs., and he was fast.

"I learned if you worked hard, stuck to it, and did it well, you got rewards later on," he said.

His coaches told him, "You'll have to be better than the white guys in college, if you're gonna play."

Millard "Steamy" Naylor, Howard's first coach, came to the school in 1926 to teach biology, business math, and history. He started a football team that year and coached for the first thirteen years without extra pay.

In his thirty-two years of coaching, he produced twenty-two teams that won more than half their games (finishing over the .500 mark), eight losing teams, and two undefeated clubs (1926 and 1939). He produced championship teams in 1933, 1939, 1949, and 1941.

Coach Naylor did more than coach; he instilled discipline, respect, and fairness.

Coach Naylor motivated the team by telling them he did not expect them to be ordinary. He meant them to be better. He taught Ed to "take out,"

to get players around the legs, and to learn tricks on how to do it. And Ed was so intense, he did not hear the cheers while he was playing. And, he says, "the girls loved his prowess." For his efforts, they rewarded him with their attention.

But he also hit people.

After a basketball game in which Howard beat Armstrong High School in Washington, D.C., a Dunbar player, angry that Howard had won, punched Ed on the side of his head as he was going toward the locker room. Ed went after him, and both teams exploded.

The police had to pull the Howard boys out of the gym and put them on buses. The next day, Baltimore's *Afro American* newspaper story said Ed had a "pugilist personality." His mother, even though outraged at him for fighting, wrote a letter to the newspaper saying that wasn't so.

She told Ed, "There is never an act without a cause." She always told him that when he got into trouble.

You might think, therefore, when in 1931-1932, Howard won the South Atlantic High School Conference championship for the first time and Ed got chosen as all-star in basketball and football, he would feel validated. But when a Baltimore reporter for the *Afro American* newspaper asked him what he wanted to be, Ed surprised him by responding, "An artist," even though Ed believed black boys from Heald Street had no chance at that.

Anger ate at him like acid. All black men have

it, he said.

"On the one hand, we were told to compete, to be the best we could be," he explained. "We only had an even chance to succeed if we excelled. Good enough did not cut it. On the other hand, our daily life showed us we did not have a chance at all."

"Of course I am angry," he told me. "I have every right to be."

At home, on the street, and in school, he felt inspired to excel. But he kept running full speed into walls of racism.

Ed's Early Years

Ed's grandmother, Hannah Jane Bratcher, was a no-nonsense, dignified, hard-working woman used to serving the gentry. When she was seventeen years old, she worked as cook and housekeeper on the Walker Pennington Farm near Limestone Road, south of Wilmington. On her day off, she would walk east to the Pennsylvania Railroad and follow the tracks to Wilmington to meet Emmanuel Loper and to shop.

After they married, she moved in with his family on Taylor Street in Wilmington. They had two children, Marian Eletta, Ed's mother, and Ralph Leroy. Not too long after Ralph was born, Emmanuel Loper left and went to New York City, changing his name to Lopez.

Marian, now four years old, was responsible

Edward Leroy Loper, Sr., at twelve years old.

Edward Leroy Loper, Sr., at thirty years old.

for taking care of Ralph while her mother went back to work.

Hannah then married Richard Govens. When Hannah's girlfriend died, Hannah and Richard took in her orphaned children, Leon and Ethel Spenser. Then, after Richard's sister died, they took in his nephews, Percy and Pete Govens. Later, they took in Edward Blackston, who simply needed a home.

Hannah worked as a housekeeper for Mr. Charles Hoopes. She thought white people were the "very best people," Ed said. Compared to Mr. Hoopes, her husband was not much. She saw Mr. Hoopes as a "great intelligence." She believed if she worked for wealthy white people, they would pay her well and her family would prosper. When she could no longer work, Mr. Hoope's wife continued to pay her $15 a month as a pension. But when Mrs. Hoopes died and Mr. Hoopes remarried, the pension disappeared.

Marian was sixteen years old when she gave birth to Edward Leroy, April 7, 1916. William Stewart, Ed's father, lived on Forest Street, a few blocks away. From Heald Street between 12th and 13th Streets, Ed looked down Cade Street and could see his grandmother Ella Fleeks' house. Unlike five-foot-one-inch Hannah and five-foot Marian, Ella was, according to Ed, "a tall, good-looking lady who smoked a pipe."

His six-foot-tall father disappointed him. "I could see how he acted around white folks, the Italians he worked for, how they treated him like a boy,

and I felt ashamed," he told me. Ed's father did not help support him. Marian did not feel William Stewart "was worth the trouble" it would take to convince him to accept responsibility.

When Ed was two years old, Marian felt hampered by her child and the lack of work opportunity in Wilmington. She left Ed in the care of her mother and stepfather and went to New York City. Ed told me he was "babied" by his Aunt Ethel, his Uncle Ralph, and his grandparents. All of them adored him and believed he was "God's gift."

Ed liked watching his grandfather work at the Beggs and Company brick-making establishment on Claymont Street.[33] Richard Govens set the kiln, putting bricks in piles inside the oven to be "cooked." Ed and his Aunt Ethel walked through large fields of daisies as they made their way to the brickyard. Their path took them east along 13th Street towards the railroad to Claymont Street and then north past the intersection of Claymont Street and Vandever Avenue. Ed enjoyed the spacious open fields and the feel of the daisies hitting against his knees. Once there, he would stand for hours and watch his grandfather work.[34]

Marian found New York disappointing, and she returned to Wilmington when Ed was about four years old. She told Ed frightening stories of the drug use she witnessed from her apartment window. She looked down to the next level and saw inside a room filled with heavy smoke. In it, Chinese men used dope and sat around with their heads nodding or

Hannah Jane Bratcher Loper (Ed's grandmother), about 1930.

Marian Eletta Loper Scott (Ed's mother), about 1945.

drifted, dream-like around the room.

"Because of her stories, I never even thought about using drugs," Ed told me.

"What about your mother's absence?" I asked him. "Did you feel abandoned?"

"No," he told me. "I was crazy about my grandmother. She raised me. I never gave it a second thought. I knew my mother did not want the responsibility of a child. That never was a mystery. And I had a wonderful family."

One night, soon after her return, Marian went to see "Ma" Rainey's traveling minstrel show perform in a tent in the field beyond 13th and Thatcher Streets. Classic blues singer Gertrude "Ma" Rainey, who began her career as a minstrel performer, provided just one of the numerous traveling shows of the late nineteenth century which became training grounds for the cultivation of black artistic talent. According to Jacqui Malone in *Steppin' on the Blues,* "Dancers, singers, and musicians shared the spotlight, maintaining the close relationship between instrumental music, song, and dance that was at the core of African-American culture."[35] When "Ma" Rainey and her band performed with The Rabbit Foot Minstrels (known as "the Foots"), she danced and sang popular songs in addition to the blues.[36] According to Charles Reagan Wilson, "almost 400 tent-show companies traveled the nation in 1925 . . . visiting 16,000 communities."[37]

During the performance Marian attended, she especially enjoyed watching one of the buck-and-wing dancers, Reese Columbus Scott. His tap dancing combined a flat-footed time step danced close to the floor with a hop and sideward thrust of one foot, typical of buck-and-wing dancing. Marian waited until the show was over and introduced herself. Charmed both by his intensity and intelligence, she went back each night of the show. Scott, equally attracted to Marian and tired of life on the road—the long days, difficult travel, demanding audiences, and low pay—did not mind settling down.

The two soon married and moved into the row house next door to Marian's mother.

"He was the best thing that ever happened to us," Ed said.

Ed and his grandparents, his Uncle Ralph, his stepaunts and uncles—Leon and Ethel Spencer, Percy and Pete Govens, and Edward Blackston—lived at 1015 East 13th Street. Marian and Reese Scott lived at 1017.

The block of row houses were of the type commonly built in Wilmington in the mid-1800s: two-story, boxy brick homes built to allow workers to live within walking distance of their jobs. Two blocks away, near the Eleventh Street Bridge, the area consisted of jerry-built "shacks floating on the stagnant water of the swamps."[38] Although Ed remembers those "shack houses" with amusement, there was nothing funny about the susceptibility of their occupants to rheumatism, typhoid, and tuberculosis.

When Ed was six years old, the whole family moved around the corner to 1221 Heald Street.

In 1927, the brick factory closed.

One Sunday, right after breakfast, the now un-employed Richard Govens opened the second-floor window as though he were going to say something to a neighbor across the street, but he kept moving, Ed said. He either leaned too far out and fell or he intended to jump. He hit the ground head first. Ed said his heart was still beating when they got to him, but he quickly died.

I must have cringed when he told me this, because Ed said in his matter-of-fact way, "Life went on. We did not complain. We had food to eat and clothes to wear and a roof over our heads."

"You must have been horrified," I said.

"I felt terrible," he admitted. "I hurt. I could not understand how he could be dead just by fall-ing out a window."

"And your grandmother?" I questioned. "How did she take it?"

"My grandmother was a resilient woman," he answered. "She could do anything. She just took over, made the arrangements, and went on. Years later, when her boyfriend Mr. Naylor died, she did the same thing. We went in the door of his house and he was on the floor with food running out of his mouth, dead. She just told me to go call Mrs. Rose, the undertaker. I found out later he died of a heart attack. She took care of things and did not look back."

"Her religion must have provided comfort," I said.

"Yes, the church mattered to her and to my mother," he told me. "We were church-going people."

The Lopers attended St. James A.U.M.P. (Afri-can Union Methodist Protestant) Church on 16th Street, between Claymont and Heald Streets, three days a week.

On Sunday morning, after a breakfast of salt mackerel, pork chops, fried potatoes, hunks of cheese, hot biscuits with butter (made the night be-fore and placed on a warming oven to rise, then kneaded, put in a pan to rise high again, and baked that morning), they attended the worship service. Then Ed went to Sunday School where he learned how to read using letter cards and simple pamphlets, and he listened to stories about Jesus, told by a young woman from the community.

On Sunday night, they attended another church service. On Monday night, they went to the Board meeting, and Ed would go to sleep on the bench in the back of the church. One night he went up to the balcony and used his fingernail to scrape through layers of paint on one of the pillars, etching a pic-ture of a woman.

On Friday night, Marian sang in the choir.

The streets leading to and from the church were filled with neighbors who went in and out of each others houses. Ed remembers walking to church in the winter, sliding his feet over the smoothness of macadamized Claymont Street. It did not feel at all like Heald Street—Heald Street's dirt surface had

ashes spread in the ruts, which created dry patches amidst the mud. He watched the moon follow him at night and enjoyed how the clouds, edged with shimmering light, created patterns in the dark sky.

Reese thought Marian was stupid to waste her time going to church. He hated church, he told her, and he refused to go.

Finally, after much cajoling, Reese relented, and reluctantly, with much complaining all the way, went with them. After a few weeks, during one of those services, Reese Scott felt the Holy Spirit enter him, and he came home "smitten," Ed said. He cried for days, went to neighbors and ranted and raved, and "got religion."

This buck-and-wing dancer, who could neither read nor write, now had a mission: to read the Bible and find out as much as he could about this God who had come to him and shaken him to his very soul.

Scott asked his next door neighbor, piano teacher Miss Henrietta Gray, to teach him to read. She had been fired as a school teacher because she had been Lemuel Price's girlfriend. Lem Price had quite a reputation.

On the morning of November 13, 1919, this twenty-four-year-old black man shot and killed a patrolman and wounded his partner as they tried to arrest him in a home on East Sixth Street in Wilmington. It took a jury seven minutes to convict Price. After his conviction, he escaped from the Workhouse and eluded capture for ten months. Af-ter an escapade encompassing several states and a short trip to France, he was finally caught committing a robbery. After his arrest, the police discovered his record through the fingerprints the Wilmington police had recorded. He was hung on December 3, 1920, at Greenbank, called Price's Corner, on the Kirkwood Highway.[39] Many Wilmingtonians contend the corner was named for Lemuel Price; however, David Price, an early white landowner, moved into an old log cabin there in 1834.[40] Price's Corner got its name because of David Price's property.

Henrietta Gray's love affair with the notorious Lem Price notwithstanding, the community idolized her because she had an education.

She began to teach Reese Scott to read and write. Then, when Howard High School started a night school, he signed up and continued his education. He began preaching in the church and soon was ordained as a minister.

People came from all around to hear his powerful and motivational sermons. Between his preaching and Marian's singing, the church thrived.

And Ed adored him.

"I watched him learn to read and write, and I saw how he took over that church and gained the respect of everyone, and I learned if you wanted something a lot and you worked very hard, you would succeed," Ed told me.

Ed attached himself to Reverend Scott, going with him to St. James' Church services. Later, he trav-

eled with him to Mount Zion Church in Merchantville, New Jersey. While Reverend Scott preached, Ed played croquet with Audrey Cream who lived next door to the church. When he was sixteen years old, her brother, Arnold Raymond Cream, had his first professional boxing bout. Known as "Jersey" Joe Walcott, he became the heavy-weight champion of boxing.

To get to Merchantville, Reverend Scott and Ed rode in an old Mormon automobile with isinglass sides buckled on it. They left home after an early breakfast. They drove out of Wilmington on Market Street, then continued on the Philadelphia Pike to-ward Claymont, north of Wilmington. By the time Ed could smell the acidic aroma of the oil refineries at Marcus Hook, the first tire went flat. Reverend Scott and Ed replaced it with the one good spare. The second tire went flat at Woodlawn Avenue in Philadelphia. This time they took the tire off, scraped it with a scratch pad, put glue on it, lit a match to melt the glue, and stuck a patch on it. Then they crossed the Ben Franklin Bridge to Merchantville, arriving in time for the eleven o'clock service.

Even though the tires always went flat, Ed never tired of the adventure.

He also enjoyed riding around town with Rev-erend Scott when he sold coal and wood. Scott would go to the coal yard and buy a ton of coal which he measured into cans and sold by the bushel in coal bags. He bought wood, sawed it into pieces, and sold it as well. Ed helped him load the coal bags

and wood onto a wagon pulled by a horse. Together they delivered it to their neighbors.

Ed's mother sold pies and sandwiches on 12th Street, a few yards past the Railroad Avenue train underpass and 100 yards from where Gander Hill Prison now is located. The Pullman Company, a manufacturing plant for railroad cars, allowed her to put a table outside the gate. As the men left for lunch at noon and for home at the end of the day, Marian sold them her food. Years later, when Ed became a painter, he saw Charles Burchfield's 1938 watercolor, *End of the Day*, a picture of men going home from work in the dark carrying their lunch pails, at the Pennsylvania Academy of the Fine Arts. It reminded him of this scene. In 1947, Ed made his own picture, *Under the Highline,* a dra-matic depiction of the massive supports of the un-derpass, the deep space beyond it, and three small figures dwarfed by swirling trees and weeds.

Reverend Scott became the most popular young minister in his conference. Marian's singing rejuve-nated the choir. Eventually, Reverend Scott was sent to St. Paul's Church on Fourth and I Streets in Wash-ington, D.C., and he and Marian moved. Ed stayed in Wilmington with his grandmother.

St. Paul's Church, struggling before Reverend Scott and Marian arrived, soon gained members and financial support.

Reese C. Scott served as General President of the A.U.M.P. Church from 1950 to 1967 and Bishop from 1967 to 1974.

He was, according to Lewis V. Baldwin, author of *"Invisible" Strands in African Methodism: A History of the African Union Methodist Protestant and Union American Methodist Episcopal Churches, 1805-1980,* a "tough-minded churchman and politician."[41]

Scott had a "can do" attitude. He believed "God would do nothing for you that you can do for yourself."[42] Aware that he had to stop the loss of churches (the A.U.M.P. conference declined from about sixty-nine congregations and small missions in 1910 to only thirty-nine in 1950), he knew he had to make it more difficult for churches to leave the conference.[43]

After reviewing the laws of incorporation, he helped pass a ruling which placed local congregations' church buildings under conference control. This deliberate attempt to prevent local congregations from breaking away assured connectional authority among the A.U.M.P. churches.[44]

In 1954, Scott stood his ground when Walter Cleaver, the General Vice President of the Conference and pastor of the St. Paul A.U.M.P. Church in Washington, D.C., refused Scott's assignment to another appointment and decided to lead his church out of the conference and become independent. Scott said Cleaver could leave the A.U.M.P. Church with his supporters, but he could not take the building and property. The dispute went before the U.S. Civil Court in Washington. Three years later, Cleaver lost, and he was forced to pay the entire cost of the court. St. Paul's Church remained in the A.U.M.P., and Cleaver and his followers built the St. Paul Chris-

tian Community Church, an independent body.[45]

In 1938, when he was the president of the A.U.M.P. Sunday School Association, Scott organized the African School of Religion in St. James A.U.M.P. Church in Wilmington. In 1950, when he took over as General President of the conference, he introduced policies designed to improve its educational work. He placed the school under the supervision of an executive committee of the general conference. He also planned Annual Conference Ministerial Programs for men and women interested in forms of Christian ministry.[46]

It's no wonder Ed remembers him with such pride.

"I always knew he was special," he told me. "I can remember people bickering in church meetings, arguing this and that with each other. And Reverend Scott would say, "I don't want to hear any 'he says, she says' in this church. Take it outside."

And they did.

In 1975, when Reverend Scott was eighty years old, Ed painted *My Father the Bishop.* Reverend Scott wore one of the black robes he and other black ministers in Washington, D.C., bought when the United States Supreme Court Justices turned the robes in for new ones.

"Try hard, and you can be anything you want to be," Ed said he learned from Reverend Scott.

So eight-year-old Edward Loper shot the tin can filled with rags over and over again, determined to be the best at whatever he did.

Fight at First Sight

Fourteen-year-old Edward Loper had two passions: sports and girls. His observations had convinced him girls liked boys who excelled at sports, and he never missed an opportunity to impress them.

So when track star Viola Cooper moved to Wilmington from Mineola, Long Island, and entered Howard School, Ed looked her over and liked what he saw. "She was nice looking," he said. "She had a solid, athletic build, with short close-cropped hair."

And she was confident, sassy, and fast.

She told Ed's friend Herman LaFate she could out run him. She did.

"So I challenged her," Ed told me. "No girl could get away with that."

He out ran her that day and won her heart as well.

When Ed and I first discussed his wife, Vi, we talked in his living room on a gloomy, cold January afternoon. He told me their daughter, Jean Marie, was born two years later, and Vi had to leave school. She moved in with Ed and his grandmother.

"In Howard School, students had to drop out of school if a pregnancy occurred," Ed said. "But the principal, Mr. Johnson, told me I was to stay. He said to tell him if any of the women teachers said anything to me."

When I objected to the double standard, Ed just

shrugged and said, "That's the way it was."

In late June 1997, I met him in Brandywine Park in front of the Wilmington Zoo where he was teaching an outdoor class. He had sprained his ankle the week before, so he, uncharacteristically, was sitting on a lawn chair as we talked.

I attempted to piece together when he had his children. Ed had told me in January that Edward Jr. was born a year after Jean, followed by Kenneth.

I told Ed I knew he had another child, because, in 1982, Ruth Anne Crawford and I attended her funeral at Scott A.M.E. Zion Church on 7th and Spruce Streets in Wilmington. When his daughter Mary died, he told me that he fathered her before he met Vi. And he told me Vi never knew about her.

Now, this day in Brandywine Park, Ed told me he was "girl crazy" as were all boys his age.

So much so, he said, smiling, sitting on his chair in the park, that while Vi stayed home with Jean Marie, he went to parties with his high-school friends and met other girls. One of them, Mary, he said, ended up pregnant after a one-time encounter with him.

He told me Mary and their daughter, also named Mary, went to Trenton, New Jersey, to live with her parents. Her family told Ed to stay away from her. His daughter Mary did not come to live with him until two years after her mother died, when she was twelve years old, and her grandparents could no longer cope with a teenager.

He admitted Vi was angry about what he had

Viola Cooper Loper in front of Heald Street home, about 1940.

done. "But I was good to her, did everything for her," he said. "It shouldn't have made her angry. Her sister's husband, St. Claire Williams, was always out with women. I merely had a few breakdowns. I couldn't maintain monogamy. When I had a breakdown, she got mad."

On my way home from the park, I wondered why he defended his behavior so adamantly. I identified with Vi and felt angry at him for betraying the woman he told me he loved and who had to leave high school because of him.

Judgment jammed my feminist craw until much later when Ed told me what really happened.

A Man of Sorrows

My next questions appeared obvious: Despite the tremendous constraints imposed by the racial and economic barriers of the times, how did Ed make the disparate parts of his life connect? I still could not understand what fueled his ambition. Uncovering meaning in visual appearances and learning what art was about do not pay the rent.

So he reminded me.

At graduation, when he received a sports scholarship to Lincoln University, he had children to support. "I felt responsible to and for those kids," he told me again.

He hunted jobs instead.

Besides, he went on, if he went to college, he could be one of three things: a minister, a teacher, or a Pullman porter. He wanted to be an artist.

"Remember," he told me, "at first all I could do to earn a living was the physical day work all black men did." He lasted one day hauling bricks and a little longer unloading cement bags from freight trains.

Since his grandmother kept insisting "no relief," he kept trying.

He applied to be a policeman. He went to City Hall in Wilmington and filled out the paperwork. Strong from his athletic training, he easily passed the physical test. He found himself helping the other applicants tie a bandage, a skill his sports training had taught him. He thought he had a chance.

Later, the janitors who worked in the building told him they saw the officer toss his application into the trash as soon as he left.

"I stayed angry all the time," he said. "All black men did."

One day he and Vi took the bus to Newark. A man got on the bus, saw them, and called them "dirty niggers."

"He was drunk," Ed told me. "It was acceptable for him to say nasty things to black people. No one on that bus cared. I wanted to hit him. I felt humiliated he called us that, especially in front of Vi. But I knew if I hit him, I'd end up in jail, and she'd have no one to help her with those kids. I just sat there. I never forgave myself."

Then Vi applied for relief, heard about the WPA,

and their lives changed.

Now he had not only a job but a school. He learned the drawing and painting skills he had craved, and he had other artists around him to answer his questions. He earned their respect.

One day, during 1940, Ed and Vi went to Howard High School to see a play. As they walked past the Allied Kid Company, he looked in the open door and saw men pulling leather out of drums with poles. "Water was running, these guys with big muscles were pulling stuff out, and I thought it was dramatic as anything," he said. This scene of men working under the shimmering lights, their muscles gleaming with sweat, pulling the wet, freshly tanned leather from drums and putting it in boxes, fascinated him.

As he looks back on it now, "It resembled a Rembrandt painting."

So he went back each night to paint, and Saul Cohen, the head of the company, watched his progress, bought the picture for $50, and asked Ed to do another one inside. Cohen sent that one to Boston, the main office.

He also offered him a job.

Ed worried that the WPA would not be refinanced. He read articles in the newspaper quoting people who said "all our money is being wasted." In 1939, funding and administrative cuts had caused concern among all the artists. Ed felt it was a matter of time before the plug was pulled and his income disappeared. And war was in the wind, causing industry to gear up. Men were leaving the WPA to work at Dravo, a boat-building factory. They were taking jobs as welders and getting much better salaries. Ed had kids to support.

Ed was earning $43.80 every two weeks at the WPA. Saul Cohen offered him $28.50 a week. He accepted the offer.

Saul tried to give Ed a job in the toggle division, but the white men who worked there threatened to strike if he did.

So Ed began doing what he had painted, working in the tanning division, pulling the wet leather out of the drums, and putting it in boxes.

Ed should not have been drafted because he had children, but he received notification on a Monday to go to Camden and report for service on the following Monday. He told his boss, Billy West. On Friday, a letter arrived telling him not to report. Ed always assumed he did not get drafted in 1940 because Saul was the head of the draft board.

After the war started, black men were given the jobs vacated by the white men who had been drafted, and black women were hired as well.

Saul Cohen moved Ed to the toggling department. There Ed worked with the toggle machine, an eight-foot-long, four-foot-wide metal table punctuated with tiny holes. He pulled the metal panels out of a heater and flipped them sideways. Then he and three other men smoothed and stretched the leather. They used both hands. Ed next put his fingers through the holes and

using a toggle, a pole with a hooked end, he stretched and pulled the underside of the leather until it snapped into the holes on the metal sheet. If he missed a snap, when he ran his fingers along the metal sheet, he cut his hands.

He was paid by the dozen. When Saul Cohen promoted him to lead his group, Ed and three other men stretched eighty dozen sheets of leather in eight hours, a Herculean feat.

Ed thrived on the long hours of intense physical work. He painted every night and visited museums on weekends. "I was young, strong, and happy," he told me. "We were doing well, Vi and I, and Jean, Eddie, and Kenny." Those were good years.

Ruth Blatt Kolber, one of Ed's neighbors, confirms this evaluation. Now eighty-one years old, Ruth moved to Wilmington's East Side from the Prospect Park area of Brooklyn, New York, when she was fifteen years old. Her father opened his first grocery store, Blatt's, "in the marshes, where Gander Hill Prison now stands," she told me. Their 13th Street house did not have central heating or indoor plumbing, a pot-belly stove provided the only warmth. When she was seventeen years old, her family moved to 12th and Heald Streets, a few houses away from Ed's family. Ed and Ruth became good friends, and she posed for him whenever he needed a model.

"They were wonderful people," Ruth told me. "Ed was handsome, intelligent, and talented. Vi was beautiful and full of life, an 'up' person. The kids were adorable, well behaved, and fun. Ed's grandmother was lovely. We were all poor together and helped each other."

What happened next devastated Ed's family and turned Ruth into a civil rights advocate.

One December evening, as Ed walked home from Allied Kid swinging his lunch pail and whistling, he saw Vi leave her cousin's house across the street. She sprinted up the street to him and ran into his outstretched arms. He wrapped his arms around her, lifted her off the ground, and spun her around. They both laughed.

The next morning, December 22, 1944, Ed had breakfast with Vi and went to work. At 11:30 a.m., his boss interrupted Ed's work and rushed him to the phone. His grandmother told him to come to the Delaware Hospital on 14th and Washington Streets in Wilmington.

He found Vi on a gurney in the hall by the elevator, where she had been since 8:00 a.m. that morning. His grandmother told him Vi had suddenly doubled over in pain, and she rushed her to the hospital. Ed knew black people were not treated until the white doctors had treated the white patients, so he was not surprised no one had even examined her.

Ed stood by her side and tried to talk to her. "She was obviously in agony," he said. "As I talked to her, I saw her eyes roll back."

Then a doctor appeared and wheeled Vi into the elevator. A half hour later, Dr. Jones returned to

Ed's wife, Viola, with (left) Eddie Jr. and Kenny, about 1938.

tell Ed that Vi had died from a ruptured ectopic pregnancy.

Jean Marie Washington, Ed's daughter, remembers that day very well.

I went to see Jean after work late one Wednesday afternoon, since her brick row house on Clayton Street close to Lancaster Avenue is only a mile from my office in Wilmington High School. Near Clayton Street, Lancaster Avenue, a busy two-lane main thoroughfare running north to south from Hockessin to Walnut Street in Wilmington, is lined with cemeteries, strip malls, grocery stores, and a post office, and I drove in heavy traffic until I turned left onto Clayton Street. The block of two-story row homes features small porches and backyards, and, on this sunny spring day, people filled the streets and the porches. We talked in her living room, where paintings by Ed and his son, Eddie, enliven the walls.

"I wanted to stay home with my mother," she told me in a soft, melodic voice. "Mama had been having a pain in her side all week. She'd stop what she was doing and just stare into space and say 'Oh, I've got this terrible pain in my side again.'"

Jean started begging to stay home. "Mama," she pleaded, "let me stay home with you. I'll take care of you. I'll get you tea."

But Vi hushed her and told her to get to school. She promised her she could have the big candy cane she wanted when she got home.

When Jean left school, she ran all the way home, bursting in the front door calling her mother. "Mama, Mama, I'm home. Where are you, Mama?"

Jean raced through all the empty rooms with that candy cane on her mind.

"Mama, Mama, I'm home."

When she got back to the front room, her cousin Ruby stopped her.

"Your Mama's dead," she said.

"I screamed at her," Jean said. "'Don't say that.' I told her. 'That's not funny.'" Just then her father and Leon Spenser came in the front door, and Jean knew her father never came home in the middle of the day.

Then her brothers, Eddie Jr., in third grade, and Kenny, in first grade, arrived home. As they approached their house they saw men from the factory milling around outside. One of them told them their mother was dead.

Eddie sat on the step outside.

"I just stood there," Jean told me. And then she stopped talking.

I watched her for a few seconds. Her eyes stared at the wall in front of her, focused on empty space, and her hands lay still in her lap. She was back in that house on Heald Street again, reliving the moment. I told her I was sorry my question about her mother's death caused her so much pain.

Then she continued, and we talked for three more hours.

When I left Jean that day, I understood the depth of the trauma the family suffered.

"When Vi died," Ruth Kolber told me, "the

whole neighborhood was distraught."

A few days later, Ed filled me in on the aftermath.

Ed said he went numb. He cried without warning and without control for three months. "At work, I'd be working and just start crying. And I started having these attacks. My heart would pound, I'd feel short of breath and almost faint," he said.

He had one of those attacks early one morning at home.

"He grabbed his chest," Jean told me, "and he said he couldn't breathe. He called Dr. Brown and then he told me to go and get some medicine from Dr. Brown. I raced through those streets as fast as I could. I thought he was dying too."

Then, at Easter, Ed's mother died from uterine cancer.

Each of them refers to these losses as the Christmas/Easter bad time.

Jean said she lost the two people in her life who talked to her and taught her things, like to wash her hands after using the bathroom and not to run her mouth too much. They would pinch her, too, if she did something wrong.

"I passed on the pinching," she said. "It fell to me to take care of those two boys, and I would pinch Kenny's arm and even twist it, because I learned that from them doing it to me."

They had also taught her some cooking, and she helped her great-grandmother, Momma Jen, as best she could.

"She couldn't see too well, and I couldn't ask her too many questions or she got annoyed," she said.

Her great-grandmother's sister, Aunt Bertha, came to help and moved into the front room with Momma Jen.

Everything changed.

Eddie Jr., a slightly built, soft-spoken man who thinks a long time before he talks, came to my house on a warm May evening. I wanted to know how he remembered those few months. He did not answer me for a few seconds, and then said that was when he started biting his fingernails. "I lost my mother at Christmas and my grandmother at Easter. I kept looking around me to see who would be next."

He told me his father became immobilized.

Ed admitted he fell apart. "I told myself I'd never get involved with a woman again, never love anyone again," he said. "About three months later, I stopped at the 12th and Poplar Street grocery store, and when the woman who owned it asked me how I was doing, I told her I was a mess and that I'd never have another woman in my life. She told me I was crazy to say that. She said she was here taking care of the store, her kids were grown and gone and never see her, her husband dead a long time, and she had nothing. She told me to get busy and find me another woman."

So he did, obsessively.

He says women started being nice to him, some out of pity, most because they found him attractive.

And it was wartime and many of their boyfriends or husbands were fighting in Europe. He worked seven days a week at Allied Kid, went out to clubs in Wilmington, Trenton, and Philadelphia with different women almost every night, and painted whenever he could fit it in.

"I didn't have to think," he said. "I just kept moving so I did not have to think. Every year since Vi died, I get depressed around Christmas. It eased up a little when I turned seventy."

Eddie Jr. simply told me, "We never saw him."

Delos O'Brian, pastor of the First Unitarian Church in Wilmington, introduced Ed to Ellen Crosman, a white reporter for the Wilmington *Sunday Star*. Reverend O'Brian thought Ed and Ellen would have a lot in common.

Ed helped Ellen photograph people for a column she was writing. One day, when she stood on a milk crate to get a better view, she asked him to put his arms around her so she would not fall.

Ed got scared.

"I was so terrified, I shook," he told me. "Black men were being lynched for being seen with white women."

But they continued to enjoy each others' company. Ed said she let him know a black man could be a worthwhile person. She helped him heal. "She really nurtured my self-esteem," he told me.

Ed wanted to marry Ellen, but he knew that was impossible. In the 1940s in Wilmington, black men did not marry white women.

Sick from overwork, exhausted from his nightly carousing, and still struggling with the anxiety brought on by suppressed grief and rage, he decided he had to do something. He could not abandon his children. If he died, they would not have either parent. He knew his grandmother was too old to raise yet another generation of kids. He knew his kids needed a mother.

So when Claudine Bruton, a worker at Allied Kid Company, started asking him how his kids were doing, he began to go out with her. Ed found Claudine soothing and dependable. He needed stability, and his children liked her.

"Kenny told her we were rich," Eddie said.

"I made a decision," Ed told me. "I had to get my life in order. I vowed to be a good husband, a responsible man, and a decent father. I wanted to have a normal life."

In 1947, his stepfather, Reverend Scott, married them.

Eddie told me this marriage continued the perception among neighbors and friends that the Loper's were rich, famous, and associated with famous people: Claudine's brother, Bill Bruton, played major league baseball with the Milwaukee Braves.

A short time later, Ed saw Ellen walking past the Wilmington Library. For several minutes, they stood and looked at each other across busy 10th Street. Then they walked on.

Ed Builds a House

Soon after Ed and Claudine married, Ed told her he wanted to show her something.

They took the trolley to Lancaster and Greenhill Avenues and walked a short distance to a series of vacant lots located behind what now is the Wilmington High School football field.

Ed told her he and Vi owned land somewhere around there. He explained to her that a mailman who had been a decent athlete at Howard School had admired Ed's sports skills. He told Ed a white woman in Wilmington was willing to sell the land to black people. He already lived there and said it was a good neighborhood to raise kids.

Ed paid $300 for two lots. The seller told him the land belonged to black people once, and she wanted them to have it back. But Vi had died before they could build a house.

"Why did you want to move?" I asked him.

"I wanted to own a house," Ed told me. "I had rented all my life. Other people in the neighborhood gave all kinds of reasons: the schools are better, the neighborhood is safer, that kind of thing. I just was tired of paying rent."

By 1949, however, the East Side had become depressed. The movement of middle-class white families from the city to the suburbs, the decline in blue-collar jobs, and the influx of poor blacks from the south all contributed to its deterioration.[47]

So he and Claudine stood there looking at dirt and weeds and tried to figure out what part of it was theirs.

Ed went to the Wilmington Savings Fund Society (WSFS) and asked for a loan. He had saved $7,500. The house would cost $14,000 to build. He wanted to borrow $7,000.

A few days later he received an answer: "No. You're a bad risk."

When he told Saul Cohen, Saul said "Sons of bitches. I'll write a letter and you take it to the Jewish Federation."

Ed took Saul's letter to the northwest corner of 9th and Shipley Streets in Wilmington, presented it to the Jewish Federation, and again asked for a loan.

A couple of days later he received a reply: "Loan approved."

Asked how he wanted to pay it back, Ed agreed to pay $50 a month. "Anytime you want to pay extra, you can," he was told. He repaid the loan in seven years instead of twelve.

Saul Cohen knew a man dying from leukemia. Saul suggested Ed hire him to build the house. Saul also provided the windows and had an electrician at Allied Kid do all the wiring on Saturdays.

When Saul Cohen died in West Palm Beach, Florida, in 1987, Ed contributed to the obituary which appeared in the *News Journal* papers and *The Jewish Voice*.[48] By then, this vice president of Allied Kid Company had received numerous awards for his philanthropic and community service: In 1960,

he was one of three nationwide winners of the Human Relations Award given by the National Council of Christians and Jews; three years later, he was awarded the B'nai B'rith Community Service Award. Both awards honored his activities, which ranged from participation in the Jewish Community of Delaware to general community programs: vice president of the executive committee of Wilmington General Hospital and on the board of directors of the United Community Fund and Group Hospital Service; director of the Greater Wilmington Development Council, the Jewish Community Center, and the Jewish Federation of Delaware.[49]

Saul Cohen was proud that Allied Kid Company, in 1932, pioneered the racial integration of its cafeteria and restrooms.

Ed honored him, in addition, for his support and encouragement of one black man, an unknown, insecure, struggling kid from Heald Street who, partly because of Saul's influence and guidance, became a teacher and artist.

"And that is how I kept going," Ed said. "Along the way wonderful people helped. Even at the worst times, good people believed in me, and my own stubborn personality never let me surrender."

Art and Golf

Ed did not stay "knocked down," but the major issues of his life also never changed.

If fourteen-year-old Edward Loper had two passions, girls and sports, forty-seven-year-old Edward Loper did too: art and golf, in that order most of the time. They remained his passions into his eighties, when, he said, he started losing golf matches to a woman.

That woman, Janet Neville, met Ed when she was forty years old and he was forty-seven. Janet, a white executive secretary for the DuPont Company, recently divorced and looking for something to do, joined his Wednesday night painting class because a good friend told her the class would be fun. Magee Slader worked with Janet at DuPont and said Ed provided interesting conversation and challenging lessons.

Janet had tried volunteer work. She worked at the Girl's Club and as a candy striper in the hospital. She felt lonely and bored.

Ed did the usual. He told her she was stupid. He told her she could not see color. He made her cry.

Six months later, at the end of class, Janet forgot her pocketbook, and on her way to work early the next morning, she knocked on Ed's door to retrieve it. When she forgot it again a few weeks later and arrived at his door at 7:30 a.m., Ed greeted her wrapped in his bathrobe and told her his wife was away.

"How about going to Philadelphia with me Saturday night?" he asked her. "I'll show you something you've never seen before."

He took her to a nightclub in Philadelphia and introduced her to jazz percussionist Mongo Santamaria. The next day they went to Atlantic City and sat on the beach and talked.

Ed told her Claudine was down south visiting her family. He told her he and Claudine did not have a good marriage because they had very little in common: Claudine did not share his interest in art.

"I took her to New York to the Museum of Modern Art and to jazz clubs, and when we got back she said she found it boring. I told her she would never have to do that again. I found other people who liked to go places and do things with me," he told Janet.

He told Janet that he and Claudine worked out an arrangement. They slept in separate bedrooms in the house. He was free to see other women. He told her he had dated another woman he met at Allied Kid company, a seamstress, but she wanted him to marry her. He did not want to divorce Claudine and marry someone else, so he stopped seeing her.

Janet and Ed started seeing each other once a week.

Soon he stayed at Janet's home in Graylyn Crest almost every day but weekends.

Janet started getting obscene calls in the middle of the night. The callers threatened her, called her vicious names, and frightened her.

At work, Janet did not speak about her relationship with Ed. Her boss, a DuPont vice president, would not have approved. Once, at a company party,

during a discussion about race relations, when his wife asked Janet if she had ever kissed a black man, Janet laughed and said "lots of times." She remains convinced they never suspected a thing.

Despite these difficulties, for twenty years, Ed and Janet maintained an open commitment to each other, traveling to France, China, Italy, Spain, across the United States, and to all the class painting locations in Provincetown, Quebec City, and Boothbay Harbor, Maine. They traveled in Ed's converted van and endured angry stares and verbal threats mostly in the United States during the 1960s and 1970s.

On evenings out, they went to Philadelphia and Baltimore to avoid Delaware people. Ed feared losing students; Janet just felt frightened in general.

When she brought Ed home to meet her family in Bloomsburg, Pennsylvania, her father told her, "Honey, you can bring him home anytime." Her mother told her it surprised her to kiss a man with a beard and a mustache. "The beard and mustache were new to her," Janet told me. "She never even noticed the color."

Two of her brothers were more difficult, she said, but eventually came around.

Ed's children accepted Janet easily.

During one of their trips to the Bay of Fundy, Ed told Janet if he ever took up golf he would beat her. She said he should come with her; she would teach him how to play.

The first time out, Ed pulled the golf cart over the tee and talked too loud when he was supposed

to be quiet. Janet told him he had to learn the proper etiquette of the game, or she would not play with him.

So he did. And he got good at it, good enough to really compete with her, but not because Janet was easy competition for him. For seven years, she won the DuPont Country Club Championship in the Women's Division. Her handicap was ten.

Ed got his down to ten after only a few months. They spiced up their game by betting ten cents a hole, payable on the spot, no credit allowed. They bet twenty-five cents for putts. When they now play at the DuPont Country Club, everyone who sees them hollers, "Who's winning today?"

Ed, as usual, became obsessed.

More often than not, students in his painting classes also received golf lessons. He taught them how to swing. He argued form. He related golf to painting, arguing that both require a "learning through the senses, not through the brain."

"You have to feel the swing," he insisted, "just like you have to let your eyes do the looking. You learn to trust your instincts."

Both Janet and Ed have shot in the 70's. But they routinely shoot in the mid to low 80's. They played golf several times a week for more than thirty years. At eighty-one years old, Ed no longer can beat her. At this point, they have about a fifteen handicap.

"We got older and we don't play as often," Janet explained.

While they shared golf and art, Janet never got used to not being married to Ed. "It bothered me terribly that he stayed married to Claudine," she said. "I wasn't raised that way."

And she never got used to the racist threats and angry looks she endured when they were seen together.

Finally, in late winter of 1987, when Ed had open heart surgery to bypass six blockages in his arteries, he realized he needed to get his house in order. During his post-operative visit with Dr. Hayes, Ed asked the doctor, "Doc, what are my chances now?" Dr. Hayes told him they were 98% to 2% in his favor.

"Thank you," Ed replied, "because I'm going to marry Janet."

"How romantic!" I exclaimed. "What did Janet think of that proposal?"

"Ask her," Ed told me.

So I did.

"That was the first I heard about it," Janet told me in her kitchen as we ate lunch one Sunday afternoon.

"My initial reaction, after all that time, was, well, he decided he needs someone to take care of him now."

"I accept his egotism," Janet told me. "If I didn't, we wouldn't be together."

On July 19, 1987, after reaching an amicable divorce settlement with Claudine, Ed and Janet were married in St. James A.U.M.P. Church in Wilmington, his childhood church on East 16th Street. Ed told Reverend Paul Henry they wanted a "real

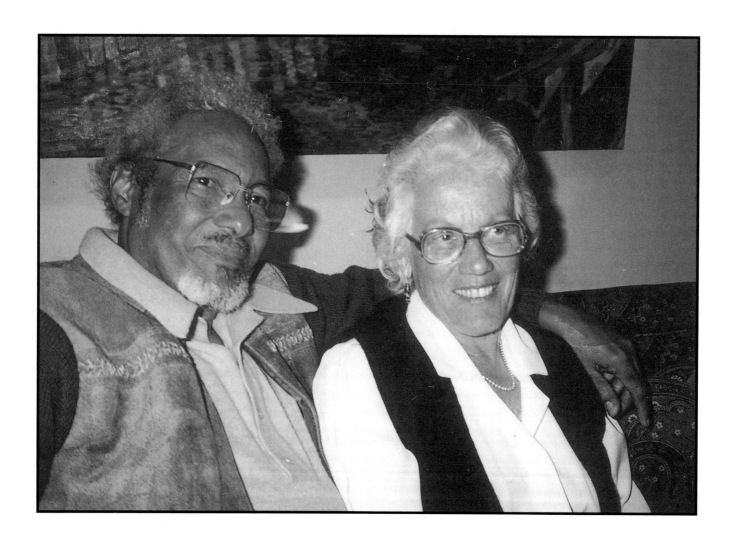

Edward L. Loper, Sr., (left) and Janet Neville-Loper, 1996.

wedding." After church, Reverend Henry announced to the congregation, "We're going to have a wedding. Anyone who wants to stay can do so."

Everyone stayed.

The choir sang. Ed and Janet stood before the minister with Ed's son, Eddie Jr., and Janet's niece, Tina Marie Veley St. Amand. Ed's daughter Jean attended the service. After the ceremony, Ed, still weak from surgery, had to hold the railing as he made his way down the outside steps of the church. Janet's hands shook as well, but from nervousness, she said.

The family shared a celebratory brunch at the Holiday Inn on King Street before going home.

The most interesting man she has ever known, Ed is also the most domineering. He never stops telling her what to do in her pictures. She gets lessons both in the studio and at home. And he never stops teaching her how to play golf. He just never stops telling her how to do everything.

"The older he gets, the more bitter he gets," Janet told me. "I hear constantly how he could not sit down and get an ice cream cone in Woolworth's on Market Street."

His rage erupts unexpectedly.

Ed spent a week teaching Janet how to improve her golf swing, and Janet felt she had improved. Ed complimented her vociferously, delighted with himself and with her. Then, as she put her clubs back into the golf bag, he screamed at her: "That's no way to put the clubs in; that's stupid."

After forty years of handling her own clubs, she endured a tirade on the "right way to do it." These outbursts mystify and depress her.

Ed explained them to me by telling me a story.

Soon after he moved into his new house with Claudine, Isadore Schagrin, one of his students, asked him if he would volunteer to take a test. Isadore knew a psychiatrist who wanted to investigate a new test designed to reveal suppressed feelings. After working with the doctor and answering questions like "when you see blue, what do you think about?" the doctor asked Ed if he knew how he felt.

Ed told him he was angry.

The doctor wanted to know if that made Ed feel bad.

Ed said no. He was angry, and he had a right to be. He also figured he would be angry for the rest of his life.

I have good reason, he told me again.

Then he recited this list, in no particular order:

He went to Carlen's Gallery and a woman was just leaving. Carlen was mad. "Know what that damn woman did?" Carlen asked him. "She wanted one of your pictures, and when I told her the price, she said, 'What does he need that kind of money for, he's black?'"

His high school football team wanted to play Salesianum, a private Catholic high school, and they couldn't play them because if they did, they were told, "there would be a race riot."

He was teaching one day along the Brandywine

River near the Doe Skin plant, and a man swimming in the river picked up a brick and told Ed to get out of there. Because the man was coming up an incline, when he went to pull his hand back to throw the brick and Ed hit him, he toppled over backwards. As he went down, he grabbed Ed's pants, ripping them. One of his students, Lee Miller, a thin, fragile older woman, always felt safe painting anywhere Ed said to go after that.

The head of the Washington Street YMCA wouldn't let him swim in the pool. He said Ed would spoil the water.

Several years ago, when he was in his seventies, at the conclusion of a football game, at an intersection in Philadelphia, Ed waited for oncoming traffic to subside so he could make a left turn. A car behind him started honking. Ed looked in his rearview mirror and saw an obviously furious man waving at him to go on. Then the man called him a "nigger." Ed sprung from his van, went up to the car, and punched the man in the face. As he returned to his van, some black men on the corner shouted, "Get him again, old man!"

When he and Vi were putting Jean on the train to visit her grandparents in Washington, the white fellows on the train pasted their faces to the window to gape at Vi and make obscene gestures.

"Bump into me," he told me, "and it's like the lid blows off a pressure cooker."

Ed Overcomes

If you met him, you'd never know it.

You'd meet an intense man with a goatee, cottony hair, and piercing black eyes. He would smile and soon start teaching you something about seeing or painting. If you met him in a restaurant, he would move plates, napkins, and silverware around on the table to show you how to create an interesting balance. If you met him on the golf course, he would point out to you how dark the sky is compared to the grass or the walkway.

He never stops teaching.

In 1996, when the Delaware Art Museum exhibited his work in a major retrospective: *Edw. L. Loper, From the Prism's Edge*, Ed received the recognition he always felt he deserved.

He taught all the way through it.

The museum staff never saw an artist attend an exhibit as often as Ed. He'd arrive just to walk through the exhibit and answer the questions of anyone who happened to be there. Generally, he ended up leading a long tour, guiding the visitors through the entire show for as long as they had questions to ask him. He led his students through the exhibit several times, and friends, family, collectors, and critics all got tours. Anyone got tours who called him and asked.

He'd arrive when the museum opened to meet a school group. Then he'd walk children through

the exhibit and unwrap picture after picture for them.

He'd answer their questions, over and over again, each time a new group arrived.

"Why do you paint? Do you see like us? How much money do you make? Did you go to art school? Why do you paint nude women?" they would ask.

One seven-year-old child became so excited about meeting the artist whose work he had just seen, he jumped up and down like a marionette being pulled by invisible strings. Ed, looking like a bemused, cuddly teddy bear, his soft curly white hair flattened by the beret he had been wearing, said "Hello, thank you for coming," as he reached out and shook his hand.

He meant it.

Later, when a group of middle school students presented Ed with a computer-generated banner reading "Happy 80th Birthday," he cried.

They huddled around him while he put his head in his hands and mumbled, "Look what you did to me."

"We didn't mean to," one said.

Ed smiled, cleared his throat, and told them he felt obligated to them. And then he began to teach.

"How do you make the sparkle come out?" one asked.

"I make it look like the light is coming through it," Ed explained, "like jewelry." He told them he put color next to color, then lighter color over the darker colors, wispy like El Greco and with bold dark lines broken by fragments of hot color.

He enjoyed himself in that museum.

When I attended the preliminary meetings for the exhibit, I sat in a room filled with arts administrators, curators, city and state government publicists, and university department chairs. I listened as they turned Ed into Edward L. Loper, Sr., a legend. The man I knew evaporated in a burst of hyperbole: "great painter; innovative; trendsetter; influential teacher; brilliant artist; living legend; Delaware's finest painter."

I left that day wondering who they were talking about.

Not that he and his work did not deserve the attention. He did. It did. I wondered, however, if every person who achieves a modicum of fame experiences this eerie sensation of unreality, as if the truth of the achievement lies somewhere else, just out of reach.

During the opening reception, attended by more than 1,000 people, the largest opening turnout in the museum's history, the legend took on even grander proportions.

Politicians praised his work. They said he represented the best Wilmington produced. From the governor, to the mayor, to the senator and representative, they said he was a great man, a great painter, a great teacher. The best.

Only one of them apologized. Senator Joseph Biden said the retrospective took too long to happen. He said he felt ashamed about that. He said he was sorry for the way Ed had been treated in his

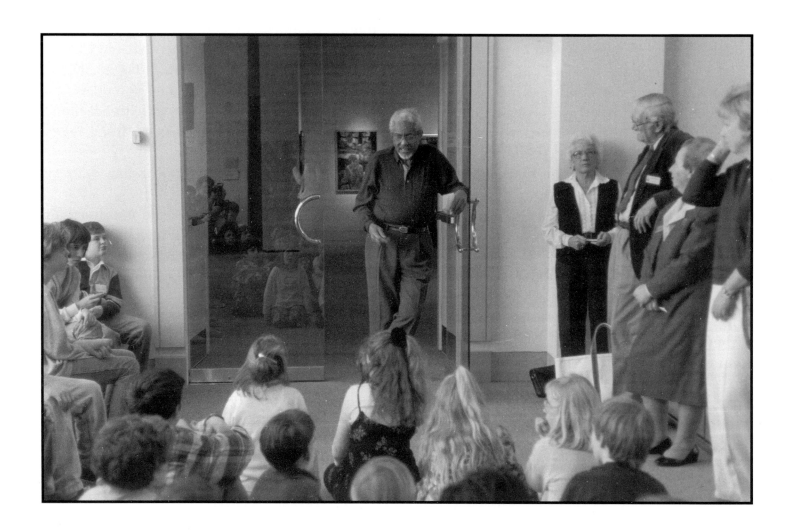

Edward L. Loper, Sr., answering children's questions about his work during his Delaware Art Museum retrospective. His wife, Janet, is on the right.

hometown and state.

The crowd got quiet at that.

While he spoke to the crowd assembled just outside the exhibit room, inside, Judy Govatos, a friend of mine, watched as two teenagers wearing bright-colored baggy pants, bulky sweaters, and Nike shoes analyzed a painting. *Gloucester Scene*, painted about 1975, impressed them. "Look at how he pulls your eye through the picture," the young man said to the young woman next to him. "See how he organizes the thrusts and counter thrusts," he said.

"Yes," she replied, "but he also balances the light and dark areas." She pulled him first to the right and then the left to show him exactly how that worked in the picture.

Standing behind them, a small old man leaned on his cane and listened to them, craning his neck to see what they were pointing to in the picture.

"What is it you see?" he finally asked them.

Both of them turned to him, then took him by the arms and walked him up to the picture. They moved him back and forth, saying "Look at the light here, look at what he does with the colors, that's how he makes the patterns."

"It isn't about that place," they told him. "It's about the meaning of his experience in that place."

"Oh, I see," he said. And he thanked them.

The two black teenagers and the old white man then moved on to another picture.

That scene came closer to epitomizing Ed's achievement than all the "hype" used to promote the exhibit. Ordinary people, moved by qualities in the pictures, communicated visual meaning across racial and generational differences.

Another incident, however, put everything into focus.

Later that spring, I went to Rehoboth Beach with my son and daughter-in-law. We decided to eat lunch at Irish Eyes, a pub on Wilmington Avenue, one block off the boardwalk.

Next to our table, a group of fifteen teenagers wearing Ulster Project tee shirts and their adult chaperons sat eating.

I listened as they discussed the Cézanne exhibit they had recently attended at the Philadelphia Museum of Art.

Then I held my breath when I heard one of the chaperons tell them he had seen the Loper exhibit at the Delaware Art Museum in February: "You know, he's a Wilmington resident, a black man, and really quite an artist," he said. He went on to tell them he thought Loper owed much to Cézanne. "He borrowed a lot of that geometric underpinning that Cézanne used," he said. "But Loper's work is richer, more fractured, and very dramatic. I wish you could have seen it. It makes an interesting contrast."

Edward Loper's work compared to Paul Cézanne's, by average people sitting in a resort pub, seemed to me to be a fitting tribute to Ed's achievement.

—*Four*—

The AfterLoper

One Step at a Time

During the summer of 1997, while still writing this book, I spent a week in Bar Harbor, Maine. I wanted to get away from the stifling Delaware heat and do something different. In short, I needed a break from my job, from writing, and from painting. I said I was going on a scouting expedition, a search for a new place to make pictures. That gave me a valid excuse to pamper myself.

I did not find a new place to make pictures. Bar Harbor did not talk to me that way. But I did do some hiking in Acadia National Park, and that experience illuminated one of Ed's most simple but important lessons.

First, you must know I have a fear of heights. I have had this fear for most of my adult life. I do not remember being particularly anxious on playground slides or jungle gyms when I was young. I can re-member climbing to the top with other kids and not minding the height. I can also remember helping my mother clean the windows of our seventh-floor apartment, and I'd sit on the sill and lean out to get the outside panes clear. No problem then.

Sometime after I had children, I recall going up a slide behind my two-year-old son, and while he had no trouble, I felt sick. After that, I noticed I hated Ferris wheels and roller coasters, and I made excuses and found someone else to accompany my kids on them. So mountain climbing, if it means open spaces, ledges, and drop-offs, would not be my thing.

However, the guide book for the Acadia Trails is a little book, very short on description. It gave no indication that what I thought was going to be a easy hike was really a rock-climbing expedition.

And what goes up, must come down.

The hike to the top of Acadia Mountain is a mere half mile to the west summit and another half mile to the east summit.

The climb up was steep, and that was the only description the guide book offered: "This is a fairly steep trail to one of the park's best vantage points for viewing the fjord, Somes Sound. You'll also observe several small islands and the open ocean beyond."

You would not have been worried either.

So I climbed up the steep, craggy rocks, followed by children and other adults, thinking that I would not like to have to come back down the same

way I was going up. But my husband had explained that the trail down was a different one from the trail up.

It sure was. It was worse.

The trail down went straight down with the vast vista of Somes Sound before me, just the kind of view that causes me to break out in a cold sweat. The rocks had narrow crevices for me to squeeze my body through. And on my right side, nothing—the drop descended to a point I could not even see.

Once I started down, I had to continue. There was no point in turning around and going the other way, because I knew what the other way was like, and I did not like it any better.

I froze. I clung to a rock, one foot wedged into a crevice and the other pressed hard on the next ledge as though glued to it, my heart pounding so hard it vibrated my backpack. If I had a cell phone, I would have dialed 911 and screamed, "Get me off this mountain."

I did not have a phone.

So I dug my fingers into my husband's sweaty shoulder and hissed, "I can't do this."

He said, "Just do it one step at a time."

In desperation, I looked at my feet. I moved one foot only when I could see the next ledge. Then I placed it and looked for the next one. I made the whole trip that way.

That is how Ed taught me to paint: one color next to another; one color at a time. And I learned to write this book one experience at a time, one word,

one sentence, one paragraph.

The work gets done that way. Therein lies courage.

That is how, in the midst of my writer's block, Anne Lamott helped me get started writing this book: "Bird by bird, buddy. Just take it bird by bird," was the advice her father gave her ten-year-old brother when he could not begin a report on birds. Lamott's wonderfully funny and seriously helpful book *Bird by Bird: Some Instructions on Writing and Life* taught me courage.

Courage makes possible the art in painting, in writing, and in life.

Eric Booth lists the blocks that lie "right in front of the starting gate."[50] Personal anxieties include: I don't know how to do this; I'm not smart enough, good enough, trained enough; I don't have the time.

I have said all these things at the start of a painting or this book. I have felt these things whenever I experience a perceived failure. My negative demon sits on my shoulder and speaks these words to me whenever I choose to listen, especially at those times I open yet another rejection letter from the Delaware Art Museum Biennial or I receive a rejection letter from a publisher.

When I compare myself and my journey to Ed and his, I see us as kindred souls, each yearning towards our entelecy, struggling to overcome internal and external obstacles, making use of accidental opportunities, and building relationships with nurturing, encouraging supporters.

Ed possessed a natural courage that became stronger in adversity. His goal: to prove wrong everyone who said he was not good enough.

He taught many of his timid students to be courageous.

Lest we backslide, he continues to teach us.

Not Good Only for Bed

In August, after I returned from Maine, I visited Ed again so I could ask more questions. I wanted him to explain to me how he selected subjects and how he made the pictures based on those subjects. And I wanted him to sum up what he thought was most important about his life and work.

Ed had just returned from two painting trips. During the first one, he visited Quebec City and Nova Scotia. During the second one, he went to Gloucester, Massachusetts. He had produced six new pictures, and he was still working on all of them.

"What do you want people to know about you?" I asked him.

I did not expect his reply.

"This damn kid," he said, "who was good only for bed, who got girls pregnant, who was considered no good, whose high school only kept him because he could play ball when others got thrown out, why was he chosen?"

While he had not answered my question, I had a feeling this was going to be an important night.

"Do you have any regrets," I asked him, again expecting an answer about painting.

He lowered his head and in a whisper said, "I would not have had a baby with Mary. That was a bad thing. I hurt Vi terribly. That is the only thing I am ashamed of."

I sat in confused silence. He looked at me for a moment and then lowered his voice even more. "I've never told this to anyone before," he said. "Not even to Janet."

"When Vi was pregnant with Jean," he continued, "we went to parties with our crowd of high-school friends. Mary had come to Wilmington to stay with a family in town, and she was at one of the parties. I liked the way she looked. So we slipped away to have sex. I was pure stupid. And she got pregnant. Her father was a minister, Reverend Miles, and he and my stepfather and the Howard High School principal, Mr. Johnson, got together. They told me they wanted me to marry her, then her family would take her to Trenton, and I'd never see her again. So I did. I could not marry Vi until ten years later, when Mary died."

He told me this so softly and with such anguish, I felt like a priest hearing a confession.

And I forgave him.

All the anger and disappointment I felt when he first told me about Mary, all the dislike I felt when he defended infidelity, drained away.

I sat there and looked at him for what seemed

like a long time, although I suspect it was only a few seconds. I felt as if I were seeing him for the first time. I also felt so close to him, so at one with his pain, it was as though I succumbed to some invisible lure. The magnetism, a mixture of respect, gratitude, and amazement, felt stronger than physical desire.

Nothing prepared me for this moment, not the years I had been his student and friend, nor the year of conversations we were close to concluding.

In that moment, I discovered that Ed, like his art, is complex, powerful, and compelling.

"Honest with himself and with others," the quality Ruth Anne Crawford found so attractive, turned out to be Ed's best virtue. It redeemed him.

I felt privileged to be so trusted, and I finally understood the catalyst sparking Ed's drive.

I knew Ed learned persistence and determination from his stepfather, Reverend Scott. I saw how Ed's own natural inquisitiveness fueled sixty years of aesthetic research and resulted in discoveries he faithfully passed on to students, making the invisible visible.

However, I now learned also that Ed concealed under all the bravado, the bullheadedness, and the conviction, a volatile mixture of repressed guilt and anger. When he was a teenager, his irresponsible behavior hurt the person he loved the most, angered another family, and disappointed his family, his high school principal, and teachers. He felt worthless. His experiences as a black boy in Wilmington during the twenties and thirties supported this judgment.

He never forgave himself. His drive to succeed, to make his family and his community proud of him, derived as much from his need to be seen as a worthwhile human being as it did from his conviction he had been chosen to do the work.

Along the way, he moved within art circles without succumbing to the snobbery or elitist superiority often associated with galleries and critics. He never lost his common touch, reinforced by his conviction that if he could learn to paint decent pictures and understand art, anyone could; consequently, he shared everything he learned with anyone who wanted to learn it. He accepted human foibles and endeared himself to countless students, men as well as women, blacks as well as whites, who, depending on their needs, related to him as a teacher, a father, a confessor, a good friend, or a lover.

In all my conversations with students, I detected no animosity, even from those who had to stop going to his classes so they could become artists on their own. I heard no bitterness, even from those who fought with him the most.

Loperism

In Art—

What, then, will be Ed's legacy?

He would like it to be color, to be known as one of the artists who took a small step to bring color to a higher level in pictures.

I pointed out to him a paragraph I read in one of the books he allowed me to borrow from his living room bookshelf, Romare Bearden and Harry Henderson's *A History of African-American Artists From 1792 to the Present.* In 1926-27, Dr. Barnes had praised Aaron Douglas's Club Ebony mural, flat figures in silhouette, merged with a curvilinear series of concentric circles. Douglas's colors were within a restrained, grayed range. At the time, Barnes admired the mural, but believed Douglas would benefit from studying at the Foundation. He offered him a tuition-free scholarship at the school plus a stipend of $128 a month.[51]

Barnes wanted Douglas to learn how to do his murals in color.

Much later, in the 1970s, when Douglas was in his seventies, he started redoing the murals in terms of color, delighted to be doing, as he put it, "things with color I didn't know how to do at the time."[52]

Ed wants to be remembered as the artist who, though primarily European and modernist, stayed grounded in mundane everyday reality. He wants his pictures to be read based on their color, their dramatic, intense color, which reverberates with vitality. He does not want them to be read based on their subjects, which are of no interest to him.

He believes he has done the work God intended him to do.

"Why was I chosen to make pictures?" he asked me again as I scribbled notes, trying to keep up with him. I knew he did not expect me to answer him.

"Now when I get confused working on pictures, I say, 'God, it is in your hands.' And the picture gets better.

"These things I don't understand. I can completely make a mess on a canvas. I don't know what to do. And then the picture starts coming together. I know I built up lots of understanding. But understanding doesn't make art. I can't believe I did it. I can't believe I still do it."

"Show me," I asked him.

We went into his living room and he pulled out some pictures propped against the fireplace.

"I look for shapes," he told me. "The objects don't matter to me. I just look for the shapes things make in a space. If the shapes appeal to me, I start to draw."

I need to add Ed likes angles, too. His eye is attracted to streets with walls, or rocky coastlines, or tenements with fire escapes. It is the geometric angles that fascinate him, not the effects of light or the picturesqueness. Nothing cute. He is all structure and substance.

First he puts lines down. He does this in smears, with twists, curls, pulls, and zigzags. His line is black and rugged. He calls it "peasant like." In other words, it is crude and strong. He does not like sophistication or polish. He does not want his ability to show.

His line positions things.

He creates directional movements of patterns and spaces. He lays down the lines for direction rather than accuracy. He works across the top of the picture, then down the sides and across the bottom. He consciously moves the eye through the picture this way. And if he has to move an object to create a more exciting movement, he does it. He also moves himself so he can see the objects from other points of vision.

He never uses a big space for the sky. He shrinks it. The sky becomes a Cézanne-like narrow band at the top of his pictures.

He elongates buildings, people, and things.

When the shapes look small to him, he starts to paint. He told me he feels terrible if the picture looks big and empty. He wants it crowded, filled up.

When he finishes the drawing, it is "almost realistic," he told me. In other words, you'd know it was a place near Peggy's Cove, Nova Scotia, and not somewhere else.

Then he does the Loper thing. He puts color next to color until he covers the canvas. He tries not to see the objects. He works out of one puddle of paint, and he keeps adding pigment to it to make the next color he sees. If he fully mixes each color, he never makes a muddy color.

When his canvas is covered, he studies it. He turns it upside down. He tries to understand what he has done.

Sometimes he doesn't know what to do.

That's when he asks God for help.

Then he starts to work on it all over again. He tries to create the quality of luminosity. That's his quality, the glow of jewelry in a dark box, the sparkle in the faceted glass prism he carries around and enjoys.

"If El Greco had used color like this," he told me, "his pictures would blast people out of the room."

He works until he can't find anything left to fix.

Still, even years later, he may find something he doesn't like, and he goes back to work again.

He studies the work of painters he thinks are great: El Greco, Cézanne, Picasso, Renoir. He believes every painter should do this. That's how artists join in the conversation. Other artists' work offers ideas, ways to solve problems.

Sometimes even his own paintings help him solve a problem. The Peggy's Cove picture gave him a problem with the sky. He went back to a picture he had done twenty years before and adapted the patterns he used for the sky to the new work, "but differently," he told me, grinning, in case I thought he was losing his creative edge.

He wants Loperism, the term coined by his students, who refer to themselves as Loperized, to equal Impressionism in familiarity and become important enough so that people will come to those rooms in the museums where his students' work is hanging.

He wants his teaching to motivate his students

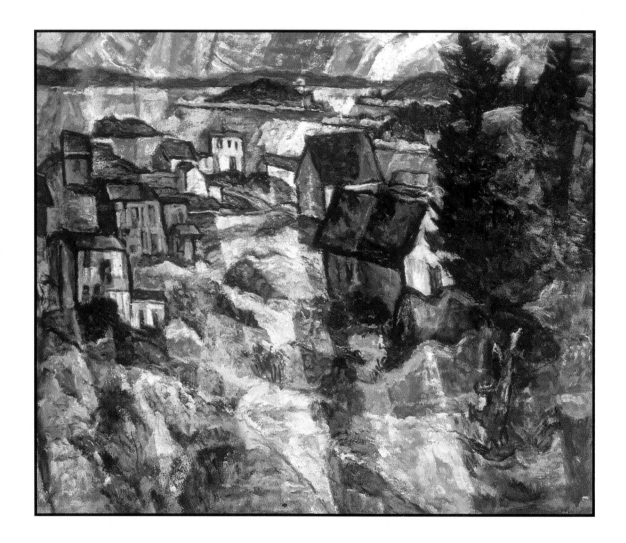

Fishermen's Village, 1997, by Edward L. Loper, Sr. Oil on Canvas; 30x36"; Collection of Janet and Edward L. Loper, Sr.

to continue the tradition he has started. He worries about a paradox: He teaches hard, everything he knows, so his students can continue to paint when he is gone; because he teaches so hard, some students, instead, become dependent on him and may be lost when he no longer guides their brushes.

Ed wants to be remembered for where he's been able to lead his students. He wants people to see what his students can do, that their pictures are different from anything that has been done before. He hopes within the next 100 years the Delaware Art Museum will hold a *Students of Edward Loper* exhibit. He thinks this would be a fitting tribute to his teaching. It would also balance the *Illustrations of Pyle's Pupils* exhibit held in the Museum's Library Gallery in conjunction with the February 3-April 20, 1980 exhibition of *Artists in Wilmington, 1890-1940.*

"At the *Students of Ed Loper* exhibit, people will be surprised by all the color and feel proud that the tradition began in Wilmington," he said. "Maybe they'll admit Delaware produced another artist and teacher as important as Howard Pyle."

"God's kept His bargain and I've kept mine," Ed told me.

In Life—

Did the retrospective at the Delaware Art Museum of Ed's work soften his sense of rejection? He says it did, if only to give him the chance to say "Ha,

I did it, Wilmington. You finally had to admit I did good work. I may not be who or what you wanted, but I am what you got."

Did the honors that followed, such as the 1998 Governor's Award for the Arts and the 1998 Honorary Doctorate from Delaware State University, help him heal? "I lived long enough, that's all," he says with a shrug. "If I had died at seventy-five, none of that would have happened."

"You sound just as angry as ever," I sigh.

He says no. He says he feels sorrow now for racist people. They live dull lives. He believes black and white people still need to get together more, go to the same churches, live in the same neighborhoods. He likes that he has been instrumental in bringing races and social classes together.

He continues, however, to always expect rejection. Although no one looks askance at Janet and him together anymore because couples like them are more common, he does not believe hatred goes away. "Now racists smile, shake hands, and cut your throat from behind," he told me.

The rage he carries within him will not die until he does. He has been scarred by racism, just as The Little Rock Nine, the nine blacks who braved hate-filled mobs forty years ago to break the all-white color barrier at Central High School in Little Rock, Arkansas, were traumatized by their experience. On September 26, 1997, the fortieth anniversary of the event, I watched the evening news on my television and saw tears run down their faces as

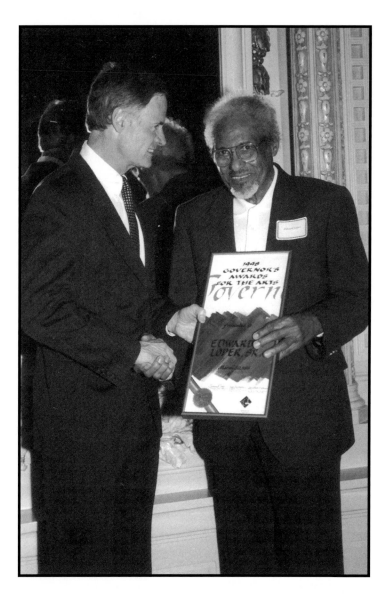

Delaware's Governor Thomas Carper (left) awards Edward L. Loper, Sr., the Governor's Award for the Arts,
March 30, 1998.

they re-told their stories, as they described the shock, the fear, and the betrayal of "adults wanting to hurt children."

I remembered reading Gregory Howard Williams' summation of his experiences in *Life on the Color Line,* his story of a white boy who discovered he was black: "I was fortunate to be able to achieve my goal of becoming a lawyer, and later my dream of being a law professor. . . . When I think of those times, I remember what Dad used to say: 'Son, one day this will all pale into insignificance.' He was wrong. Muncie [Indiana] has never paled into insignificance. It has lived inside me forever."[53]

Ed marvels that the kid who grew up "over Eleventh Street Bridge" can now afford to eat out at the Fox Point Grill, an upscale restaurant on Lea Boulevard, east of Wilmington. When he and Janet go there for dinner, he is greeted like a celebrity.

And he is happy. "Even though it has been horrible sometimes and unfair sometimes, I've enjoyed every minute of it."

I know he has, and he still does.

Wilmington's Hidden Treasure

Edward L. Loper, Sr., fulfilled his obligation to God.

His Messianic quest to reveal power and drama in everyday things taught people how to see. Those who studied his pictures or heard his preaching had their vision transformed: They quite literally never saw their world the same way again.

He performed his miracles with oil paint on canvas and through sermons, proclaiming a gospel of color. An unlikely prophet, untrained and imperfect, he remained focused on his mission, never doing less than the best he knew how.

Wilmington, Delaware, his home town, for too many years, thwarted, ignored, dismissed, or ridiculed his effort.

"Loper students are just a bunch of housewives," Bill Frank told me more than twenty years ago when I asked him to provide *News Journal* coverage for a student exhibit.

I had been baited, and I bit. Bill Frank later told Ed I "jumped down his throat," as I recited the names of the professional artists, lawyers, accountants, doctors, nurses, teachers, administrators, secretaries, and construction workers represented in the exhibit.

Despite my experience, I found out later from Ed, Bill Frank supported him and championed him every chance he got.

In fact, on January 18, 1980, Bill wrote me a typed note, full of corrections made in black marker. I had sent him a manuscript that later became "Loper: Fiery teacher who demands the best,"[54] a story about Ed's teaching the *News Journal* printed in 1981.

He wrote: "What it does give me, for the first time, is how he treated his students, praised them,

ridiculed them, beat them down and built them up. But now, what about the life story of Loper?"

I wish Bill had lived to read this book. If he had, I could now answer his note. I would say, "Here it is, Bill, finally, this book, my testament to the art and life of Edward L. Loper, Sr.

Illustrations

Collection of Janet and Edward L. Loper, Sr. Photo by Carson Zullinger Page 71.

9. Ed and I used the same subject to make these two paintings. Compare and contrast them to see if you agree with Violette de Mazia's conclusion.

> *Still Life*, 1990, by Marilyn Bauman
> Oil on canvas
> 40 x 36 "
> Collection of Marilyn Bauman
> Photo by Carson Zullinger Page 79.

> *Still Life with Basket and Fruit*, ca. 1991, by
> Edward L. Loper, Sr.
> Oil on Canvas
> 36 x 46 "
> Collection of Ellen and Jim Semple
> Photo by Carson Zullinger Page 80.

10. Edward Leroy Loper, Sr., at twelve years old. Page 87.

11. Edward Leroy Loper, Sr., at thirty years old. Page 88.

12. Hanna Jane Bratcher Loper (Ed's grandmother), about 1930. Page 90.

13. Marian Eletta Loper Scott, about 1945. Page 91.

14. Viola Cooper Loper in front of Heald Street Home, about 1940. Page 98.

15. Ed's wife, Viola, with (left) Eddie Jr. and Kenny, about 1938. Page 102.

16. Edward L. Loper, Sr., (left) and Janet Neville-Loper. Page 110.

17. Edward L. Loper, Sr., answering children's questions about his work during his Delaware Art Museum retrospective. His wife, Janet, is on the right. Photo by Alisa Colley Page 114.

> 18. *Fishermen's Village,* 1997, by Edward Loper, Sr.
> Oil on Canvas
> 30 x 36"
> Collection of Janet and Edward L. Loper, Sr.
> Photo by Carson Zullinger Page 122.

19. Delaware's Governor Thomas Carper (left) awards Edward L. Loper, Sr., the Governor's Award for the Arts, March 30, 1998. Photo courtesy of Terence Roberts Page 124.

End Notes

[1] See "A Student's View" in *Edw. L. Loper, From the Prism's Edge*, A Retrospective Exhibition at the Delaware Art Museum, February 2-April 7, 1996, 13-16.

[2] See Silliman, 81, and Ungar "Where hope and pride prevail," A1.

[3] William Henry Williams includes a photograph of students studying in the library of Howard High School, 131. Carol Hoffecker in *Wilmington: Pictorial History* includes a photograph of the Howard High School on Twelfth and Orange Streets, 151, and in *Corporate Capital,* a history of Howard High School, 94-95. For a history of Delaware's schools and the development of its black schools, see *The Mediator*, 57-72.

[4] Booth, 32.

[5] For a description of Delaware's roads, bridges, and railways from 1609-1937, see Lincoln, 215-234.

[6] See Hoffecker, *Wilmington, Delaware,* 59, and Grier, 29-30, for a description of Wilmington roads. The granite slabs with even surfaces placed at intersections were easier on pedestrians; the rubble-paved streets provided a sure foothold for horses and were easy on carriage wheels; macadamized French Street was dusty in dry weather and covered with a thin layer of mud in wet weather, but the surface was firm and smooth. By the mid-1890s, Wilmington roadways consisted of nine miles of granite surfaces, six of brick, and thirteen of macadam (small broken stones pressed together). Many roads on the East Side, like 13th Street, remained packed dirt and ashes.

[7] For a detailed account of Jeannette Eckman's contributions, see Bill Frank's column "Remembering Miss Eckman," in the *Sunday News Journal*, 30 May 1982: H5.

[8] McDonald, 448.

[9] *Speaking Dog* is reproduced in Christensen's book, #292, 148.

[10] A photograph of the iron railing on the steps of the Woodward Houses in Wilmington can be seen in *Delaware: A Guide to the First State*, 156.

[11]John Moll's illustrations are reproduced in *Delaware: A Guide to the First State*, 2, 19, 28-29, 121, 158, 160, 320-321, 467, 477, 479.

[12]Frank, "The Lopers," H5.

[13]Frank, "The Lopers," H5.

[14]Berkow, 1; Section 8, 3.

[15]This painting is now part of the Barnett-Aden Collection at the Museum of African-American Art, Tampa, Florida.

[16]See "City Painter's Art is Praised," 18.

[17]See Silliman, 28-29, for a review of Wilmington's motion picture theatres.

[18]See Hyland's description of N.C. Wyeth's working style, 39-59, and Reese's description of N.C. Wyeth's contribution to the Brandywine Tradition, 218-225.

[19]For a full description of the development of the Wilmington Society of the Fine Arts, see the pamphlet in the Delaware Art Museum Library written by Constance Moore for the 50th Anniversary Celebration. See also Reese, 213-218.

[20]Stein, 14.

[21]See Stein's account of the Carlens' family and friends, 14-15.

[22]Quoted in Werner, 43.

[23]Dewey et al., 105-122.

[24]Barnes, "Plastic Form," in *Art and Education*, 105.

[25]Ibid., 107-108.

[26]For a description of Carlen's relationship with Albert Barnes, see Stein, 16-19.

[27]Deckom, 24.

[28]Frank, "Garish ship on glassy ocean," 12.

[29]Booth, 49.

[30]Ibid., 57.

[31]Ibid., 289.

[32]Ibid., 192.

[33]Grier describes this brick yard, 140-141. James H. Beggs with John P. Allmond as his partner operated it on Claymont Street north of Vandever Avenue. Wilmington discouraged frame construction

early in its history and legislated against it in 1909. One of the early brick-manufacturing projects started by James H. Beggs and Company brought into the business expert brick makers from abroad. Grier says this enabled the company's workmen to turn out an artistic project as well as bricks used for ordinary building purposes.

[34]The Archives of American Art contain two lengthy, detailed interviews of Edward Loper, Sr.: one conducted on March 26, 1964, by Richard K. Doud and another conducted on May 12, 1989, by Marina Pacini. I reviewed many of the incidents from these interviews with Ed and asked him to recollect the experience. In so doing, we discovered several inaccuracies: in the Pacini interview, on page 54, one of Ed's students is referred to as Judy Bland; her name was Judy Blam. On page 56, Pacini says Carlen told Ed to get a book of Rousseau's work; it was Rouault. In the Doud interview, on page 18, Miss Violette de Mazia is referred to as Mrs. Masie. Another interview, conducted on January 25, 1985, by Laurie Weitzenkorn for the Index of American Design, contains detailed information concerning the making of the Index plates. Brian Miller's master's thesis, *Edward L. Loper, Sr., Artist and Educator: An Oral History,* provides another long interview of Edward Loper and seven interviews with students.

[35]Malone, 58.

[36]Ibid., 63.

[37]Quoted in Malone, 63. For full reference, see "Traveling Shows," in the *Encyclopedia of Southern Culture,* 1248.

[38]Hoffecker, *Corporate Capital,* 28.

[39]For Lemuel Price's story, see Conner, 1.

[40]To read about the origin of Price's Corner, see Wilson, 29.

[41]Baldwin, 165.

[42]Ibid., 156-157.

[43]Ibid., 156.

[44]Ibid., 167.

[45]Ibid., 167.

[46]Ibid., 173.

[47]See William Henry Williams, 128. Includes a 1949 photograph of 14th Street between Claymont and Heald Streets, not far from Ed's home.

[48]See "Saul Litant Cohen, Former Del. Community Leader, Dies," 54, and "Saul Litant Cohen, 89;

civic and business leader," B10.

[49]See "Human Relations Awards Won by Buck, Cohen, Robinson," 3, and "Saul L. Cohen to Get '63 B'nai B'rith Award," 26.

[50]Booth, 264.

[51]Bearden, 134.

[52]Quoted in Bearden, 135.

[53]Gregory Howard Williams, 284-285.

[54]Bauman, E 1.

Works Cited

Baldwin, Lewis V. *"Invisible" Strands in African Methodism: A History of the African Union Methodist Protestant and Union American Methodist Episcopal Churches, 1805-1980.* ATLA Monograph Series, No. 19. Metuchen, New Jersey: The American Theological Library Association and The Scarecrow Press, Inc., 1983.

Bauman, Marilyn. "Loper: fiery teacher who demands the best." *Sunday News Journal*, 22 March 1981: E 1, E 3.

Bearden, Romare and Harry Henderson. *A History of African-American Artists From 1792 to the Present.* New York: Pantheon Books, 1993.

Berkow, Ira. "He Crossed Color Barrier, But in Another's Shadow." *The New York Times*, 23 February 1997: 1; Section 8, 3.

Booth, Eric. *The Everyday Work of Art.* Naperville, Illinois: Sourcebooks, Inc., 1997.

Christensen, Erwin O. *The Index of American Design.* New York: The Macmillan Company, 1950.

"City Painter's Art is Praised." *Journal-Every Evening*, 30 April 1945: 18.

Conner, William H. "Nodding Noose Nips Lem Price." *The Sunday Star*, 24 March 1946: 1.

Deckom, Otto. "Loper pictured as painting self into stylistic corner." *Morning News*, 14 September 1964: 24.

Delaware: A Guide to the First State. Compiled and Written by the Federal Writers' Project of the Works Progress Administration for the State of Delaware. Jeannette Eckman, editor. New York: The Viking Press, 1938.

Dewey, John, et al. *Art and Education: A Collection of Essays.* 3rd ed. Merion, Pennsylvania: The Barnes Foundation Press, 1954.

Doud, Richard K. "Tape Recorded Interview with Edward Loper, Wilmington, Delaware: March 26, 1964." Selected Interview Transcripts From the Oral History Collection of the Archives of American Art.

Edw. L. Loper, From the Prism's Edge. A Retrospective Exhibition at the Delaware Art Museum, February 2-April 7, 1996. Lise Monty, editor. Delaware Art Museum, 1996.

Frank, Bill. "Garish ship on glassy ocean." *Morning News*, 30 April 1976: 12.

Frank, Bill. "The Lopers." *Sunday News Journal*, 21 March 1982: H5.

Frank, Bill. "Remembering Miss Eckman." *Sunday News Journal*, 30 May 1982: H5.

Goodrich, Lloyd. *Max Weber*. New York: The Macmillan Company, 1949.

Grier, A.O.H. *This Was Wilmington, A veteran journalist's recollections of the "good old days."* Wilmington, Delaware: The News Journal Company, 1945.

Hoffecker, Carol E. *Corporate Capital, Wilmington in the Twentieth Century*. Philadelphia: Temple University Press, 1983.

Hoffecker, Carol E. *Wilmington, Delaware: Portrait of an Industrial City 1830-1910.* Charlottesville, Virginia: University Press of Virginia, 1974.

Hoffecker, Carol E. *Wilmington, A Pictorial History.* Norfolk, Virginia: Donning Company, 1982.

Horace Pippin. Washington, D.C.: The Phillips Collection, 1976.

"Human Relations Awards Won by Buck, Cohen, Robinson." *Morning News*, 15 December 1959: 3.

Hyland, Douglas K.S. *Howard Pyle and the Wyeths: Four Generations of American Imagination.* Memphis Brooks Museum of Art, 1983.

Instructions for Index of American Design. Supplement No. 1 to the Federal Art Project Manual. Holger Cahill, Director. National Archives of American Art, Reel # 2814.

Lincoln, Anna T. *Wilmington Delaware: Three Centuries Under Four Flags 1609-1935.* Rutland, Vermont: The Tuttle Publishing Company, 1937.

Malone, Jacqui. *Steppin' on the Blues*. Urbana: University of Illinois Press, 1996.

McDonald, William. *Federal Relief Administration and the Arts*. Ohio: Ohio State University Press, 1969.

The Mediator. Publisher and Editor, J.F. Harlan. Wilmington, Delaware: The Progressive Press, 1920.

Miller, Brian Scott. *Edward L. Loper, Sr., Artist and Educator: An Oral History.* A thesis submitted to The College of Fine and Professional Arts of Kent State University in partial fulfillment of the requirements for the degree of Master of Arts in Art Education. August 1998.

Pacini, Marina. "Interview with Edward Loper for the Archives of American Art at Mr. Loper's home in Wilmington, Delaware, May 12, 1989."

Reese, Lee. *The Horse on Rodney Square.* Wilmington, Delaware: The News-Journal Company, 1977.

Rodman, Selden. *Horace Pippin*. New York: The Quadrangle Press, Inc., 1947.

"Saul L. Cohen to Get '63 B'nai B'rith Award." *Morning News*, 17 April 1963: 26.

"Saul Litant Cohen, 89; civic and business leader." *The News-Journal*, 19 March 1987: B10.

"Saul Litant Cohen, Former Del. Community Leader, Dies." *The Jewish Voice*, 3 April 1989: 54.

Silliman, Charles A. *A Time to Remember 1920-1960*. Wilmington, Delaware: Kaumagraph Company, 1962.

Stein, Judith E. *I Tell My Heart: The Art of Horace Pippin*. New York: Universe Publishing, 1993.

Story, Ala. *Max Weber. First Comprehensive Retrospective Exhibition in the West (1881-1961)*. The Art Galleries, UCSB. The Regents, University of California, 1968.

Ungar, Laura. "Where hope and pride prevailed." *The Sunday News Journal*. 1 March 1998: A1, A11.

Weitzenkorn, Laurie. "Interview with Index Artist Edward Loper." On file with the Index of American Design, National Gallery of Art, Washington, D.C.

Werner, Alfred. *Max Weber*. New York: Harry N. Abrams, Inc., 1975.

Williams, Gregory Howard. *Life on the Color Line*. New York: Penguin Books, 1995.

Williams, William Henry. *The First State: An Illustrated History of Delaware*. Northridge, California: Windsor Publications, Inc., 1985.

The Wilmington Society of the Fine Arts 1912-1962. Pamphlet written by Constance Moore for the Wilmington Society of the Fine Arts, 1962. On file in the Helen Farr Sloan Library, Delaware Art Museum.

Wilson, Charles Reagan. "Traveling Shows." *Encyclopedia of Southern Culture*, eds. Charles Reagan Wilson and William Ferris. Chapel Hill: University of North Carolina Press, 1989: 1247-49.

Wilson, W. Emerson. "Old Log Cabin Really Not So Old." *Morning News*, 30 March 1962: 29.

About the Author

Marilyn A. Bauman's relationship with Edward L. Loper, Sr., spans thirty years, and she credits him with transforming her vision and changing her life.

She is executive director of the Delaware Institute for the Arts in Education, a position which allows her to bring aesthetic education programming to Delaware's teachers and their students.

Her articles about art and artists have been published in *Delaware Today* magazine and the *Wilmington News Journal.* An essay in which she describes the value of the creative experience is included in the 1981-82 *Vistas* (the journal of the Barnes Foundation), and an essay in which she explains the role of tradition in aesthetic appreciation is included in the 1984-86 *Vistas.*

Marilyn's oil paintings have been accepted by many national juried shows; they have also won numerous prizes, most recently a best in show award at the 1998 Rehoboth Art League Member's Show and a first prize in the 1997 Rehoboth Art League Member's Show.

Her pictures are included in the State of Delaware Division of Libraries Collection, the Sussex County Family Courthouse Collection, the Unionville High School PTA Collection, the Wilmington Trust Company Collection, MBNA America Collection, E.I. du Pont de Nemours Inc., Collection, the Blount Collection of American Art, and many private collections.

Marilyn A. Bauman received a master's degree in English from the Pennsylvania State University in 1965 and subsequently taught at the University of California at Davis, the Community College of Delaware County, West Chester University, and the University of Delaware, where she was nominated for an excellence in teaching award in 1982.

Edward L. Loper, Sr., The Prophet of Color: A Disciple's Reflections is her first book.

Marilyn lives in Wilmington, Delaware, with her husband, Don, and their retired racing greyhound, Blaze.